1991

Jasper Johns Work Since 1974

Jasper Johns Work Since 1974

Mark Rosenthal Philadelphia Museum of Art

Jasper Johns: Work Since 1974

Philadelphia Museum of Art
October 23, 1988–January 1989

Made possible by generous grants from The
Bohen Foundation, the National Endowment for
the Arts, and The Pew Charitable Trusts, and an
indemnity from the Federal Council on the Arts
and the Humanities.

The exhibition was initially organized by the
Philadelphia Museum of Art for the United
States of America Pavilion at the 43rd Venice
Biennale (June 26–September 25, 1988) where
it was made possible in part through support
from the Fund for U.S. Artists at International
Festivals and Exhibitions, a joint initiative of the
Rockefeller Foundation, the U.S. Information
Agency, and the National Endowment for
the Arts.

Edited by Carolee Belkin Walker
Designed by Phillip Unetic
Printed by Princeton Polychrome Press
Copyright 1988 by the Philadelphia Museum
of Art.

First published in the United States of America
in 1988 by Thames and Hudson Inc.,
500 Fifth Avenue, New York, New York 10110

First published in Great Britain in 1988
by Thames and Hudson Ltd, London

First paperback edition 1990

Library of Congress Catalogue Card No. 88-50233

Printed and bound in the United States of America

Contents

Preface

It is both an honor and a profound pleasure for the Philadelphia Museum of Art to present an exhibition devoted to the work of Jasper Johns. Surprisingly, for an artist whose images have become so much a part of contemporary visual consciousness, there have been all too few opportunities for the public to see Johns's recent work. Given the extraordinary richness of cross-references and the cumulative intelligence offered by a group of these paintings and works on paper, it seemed important and timely to bring these to a wide international audience more than a decade after the retrospective exhibition organized by the Whitney Museum of American Art in New York, which was also seen abroad in London, Paris, Cologne, and Tokyo. Springing from the invitation to make a proposal on behalf of the Museum for the United States Pavilion of the 43rd Venice Biennale, Mark Rosenthal's conception of the present exhibition has proved extraordinarily felicitous. The International Prize of the Biennale was awarded to Johns, and the pavilion, elegantly renovated for the occasion, received thousands of enthusiastic visitors from all over the world. The presentation of the exhibition in Philadelphia now affords the American public the chance to see a remarkable body of work, especially in the context of the Museum's distinguished holdings of twentieth-century art. The occasional appearance of Marcel Duchamp's profile within Johns's paintings reminds us of the ongoing importance to Johns of that enigmatic master, whose spirit is so concentrated in Philadelphia's collections.

Johns's art has always had an aspect of intensely personal reflection, seemingly without ambition to persuade, to admonish, or even to address its viewers directly. Yet, as these seductively painted and worked surfaces compel our attention, we are drawn to explore the complex web of images they contain, and we can find much within them to preoccupy us. It is characteristic of Johns that the physical structure of much of his painting, colored pigments in hot wax spread over fragments of newspaper, tacitly suggests a metaphysical structure—complex thoughts and feelings flowing over the myriad daily events that mark the relentless passage of time.

The work shown here culminates in the four paintings of "The Seasons," which have already assumed a magisterial position in Johns's work. Not a subject much taken up by twentieth-century artists, "The Seasons" suggest

contemplation of human life as subject to the mighty and ineluctable course of nature, which penetrates even to the sanctuary of the artist's studio. The artist can only confront such immensity with his familiar tools and symbols, and Johns's repertory of images—the American flag, the Mona Lisa, Duchamp's profile—is now enlarged to include a bilingual sign that warns us of the danger of falling ice. In these parlous times, and they *are,* it is the presence among us of great artists that comforts and gives us dignity.

The Museum is deeply grateful to all those institutions and individuals who made this international project possible. The enthusiasm and energy of Susan Flynt Stirn, Program Manager of Arts America, and her colleagues at the United States Information Agency, and the splendid cooperation of Philip Rylands, Deputy Director of the Peggy Guggenheim Collection in Venice, and Clemente di Thiene, on his staff, were essential to the organization of the exhibition and the careful preparation of the U.S. pavilion to receive it and future exhibitions. The wise counsel of Thomas N. Messer, Director of The Solomon R. Guggenheim Foundation, was invaluable, and we are also much indebted to John L. Tancock, Senior Vice President of Sotheby's, New York, for his assistance. Leo Castelli and his late wife, Toiney, were passionate and most helpful advocates of the project from its inception. Without the financial support of the USIA, the National Endowment for the Arts, the Rockefeller Foundation, and The Bohen Foundation, the exhibition could not have been presented in Venice. Generous grants from The Pew Charitable Trusts funded initial research and planning and support the exhibition in Philadelphia. An indemnity granted by the Federal Council on the Arts and the Humanities has been crucial to reducing costs. Our heartfelt thanks go to the lenders, whose admiration for Jasper Johns has been matched by their sympathetic generosity in sharing works in their collections with the public.

Elsewhere in this catalogue, Mark Rosenthal, the Muriel and Philip Berman Curator of Twentieth-Century Art, has expressed his gratitude for all the many forms of assistance received in support of this project, from colleagues both within the Museum and without, which is here most warmly seconded. It should be noted that Sandra Horrocks, Manager of Public Relations, with the capable and deftly bilingual assistance of Carl Brandon Strehlke, Adjunct

Curator of the John G. Johnson Collection, achieved miracles of organization for the reception of the international press in Venice. Dr. Rosenthal's own devoted and thoughtful attention to every aspect of the realization of the exhibition has been exemplary, and his illuminating text for this volume adds much to our understanding of the artist. It has been, above all, a pleasure to work with Jasper Johns, who has been unfailingly helpful and generous with his time throughout the inevitably complex process of organizing such a venture. There is no adequate way to thank him for the extraordinary beauty and gravity of his work.

Anne d'Harnoncourt
The George D. Widener Director

Lenders to the Exhibition

Bayerische Staatsgemäldesammlungen, Staatsgalerie moderner Kunst, Munich Lent by Prof. Peter and Irene Ludwig

Mr. and Mrs. Asher B. Edelman and Mildred Ash

Mrs. Victor Ganz

Jasper Johns

Philip Johnson

Leonard I. and Jane Korman

Kunstmuseum Basel

Robert and Jane Meyerhoff

The Museum of Fine Arts, Houston

The Museum of Modern Art, New York

Mr. and Mrs. S. I. Newhouse, Jr.

Petersburg Press

The Tate Gallery, London

Virginia Museum of Fine Arts, Richmond

Morris L. and Mildred L. Weisberg

David Whitney

Acknowledgments

There could hardly be a more extraordinary stroke of good fortune for a curator than the opportunity to organize an exhibition and a catalogue devoted to the work of Jasper Johns, and I am grateful to the artist for allowing me this chance. In our hours of conversation, I have learned a great deal from him. I am especially appreciative of the many courtesies extended by Leo Castelli. Sarah Cooke, the artist's assistant, has been extremely helpful with a multitude of details, as has James Meyer.

At the Philadelphia Museum of Art, Elizabeth Janus, Research Assistant, Twentieth-Century Art, has had a primary role in virtually all aspects of the exhibition and has organized the bibliography and exhibition history. Margaret Kline, Research Assistant, Amy Ship, formerly Research Assistant, and Ann Temkin, Assistant Curator, made useful contributions. Suzanne Wells, Coordinator of Special Exhibitions, Suzanne Penn, Associate Conservator, Irene Taurins, Registrar, and Grace Eleazer, Associate Registrar, formed the team charged with handling the complex and demanding requirements of this international project. For their work on the catalogue, I want to acknowledge Carolee Belkin Walker, Editor, and Phillip Unetic, Designer, as well as George H. Marcus, Head of Publications, and Charles Field, Production Manager. Lorenzo Pezzatini provided the translation for the Venice Biennale edition.

I thank the lenders for so generously parting with their fragile and beloved treasures. In addition, I am grateful for the help of Christian Geelhaar, Kunstmuseum Basel; Peter C. Marzio and Alison de Lima Greene, The Museum of Fine Arts, Houston; Alan Bowness and Richard Francis, The Tate Gallery, London; William Rubin, Cora Rosevear, Bernice Rose, and Albert Albano, The Museum of Modern Art, New York; Susan Halper, Asher B. Edelman Collection, New York; Paul N. Perrot and Frederick R. Brandt, Virginia Museum of Fine Arts, Richmond; and Carla Shulz-Hoffmann, Bayerische Staatsgemäldesammlungen, Munich. Other colleagues who kindly extended assistance were Kerry Brougher, The Museum of Contemporary Art, Los Angeles, and Nan Rosenthal, National Gallery of Art, Washington, D.C.

Jasper Johns, Mark Lancaster, and Anne d'Harnoncourt read my manuscript and made many valuable suggestions for which I am most grateful. —MR

Introduction "The Condition of a Presence"

During the late 1950s Jasper Johns helped set forth an alternative to Abstract Expressionism in the United States. His appropriation of immediately recognizable imagery—American flags, targets, and numbers—resulted in a more public, apparently less introspective approach than was then prevalent, and his work was distinct for being premeditated, ironic, and detached. During the 1960s Johns turned to more private and hermetic imagery, yet his art still held a central position in terms of its effect. The impact of his work has been extraordinary in the postwar period, for his investigations of style, subject matter, meaning, emotion, systematic organization, and serial imagery strongly influenced the most important artistic developments of the 1960s and early 1970s in the United States. Since the mid 1970s Johns's overall focus has changed, and he has turned with increasing absorption to the history of art. As if to reinforce his altered ambition, Johns responded in 1973 to a question about whether contemporary art is a critique of the past by asserting that "old art offers just as good a criticism of new art as new art offers of old."[1]

Johns has carefully looked at the past, formulating a compelling personal meditation on what it means to be an artist at this moment in history. Formalism, whether manifested as abstraction from reality, nonobjectivity, or commitment to the physical characteristics of the work of art, remains a dominant issue for him. But, in contrast to his oftstated earlier position, "I don't want my work to be an exposure of my feelings,"[2] he has, in this current phase of his career, examined the work of artists revealing heightened expression, such as that of Mathis Grünewald, Edvard Munch, and Pablo Picasso. Increasingly, Johns utilizes conventional iconographic images suggestive, for example, of vanitas, mortality, and the stages of life, as well as such familiar formats as the triptych, diptych, and predella. While continuing to explore still-life traditions, he has also examined portraiture. Turning toward fundamental premises and art-historical conventions, Johns integrates and tests himself with regard to his forebears yet, as always, retains a characteristic doubt and uncertainty that is, as well, part of the modern condition.

This survey of the recent work of Johns begins with the so-called crosshatch paintings that were shown in 1976 at the Leo Castelli Gallery in New York,

which signaled a dramatic new direction for his art, and concludes with "The Seasons," so different in outward appearance. Together these paintings present, at first viewing, a dichotomy equal to the emotional states described by the artist in his statement: "Art is either a complaint or appeasement."[3] Generally quiet in tone, the crosshatch compositions of the 1970s and early 1980s seem conciliatory; essaying the modern tradition of abstraction, they may be seen as a gesture of "appeasement" toward the bogies that were evident in society and to some extent in Johns's own art of the 1960s. At the other end of this survey are recent works that are perhaps more personally expressive than any others in his career. In these, Johns is no longer interested in masking his feelings and experiences or "referential aspects."[4] Here is the "complaint," the expression of an individual's discontent in the face of transition, age, and death.

There is a development, then, from the crosshatchings to "The Seasons," in which Johns's art becomes increasingly expressive and exclamatory, concerned less with processes—except those that human beings endure—and more with thematic material. This evolution is perhaps not as exaggerated as it at first appears, however, and a wholeness can be discerned in the cycle of pictures that might be understood in the following context, written by Johns:

The condition of a presence.
The condition of being there.
its own work
its own
its
it
its shape, color, weight, etc.
it is not another (?)
and shape is not a color (?)
Aspects and movable aspects.
To what degree movable?
Entities
splitting.[5]

In the crosshatch paintings and drawings a sense of presence, being, or "breathing,"[6] is projected. After starting in this way, with virtually no external allusions, the artist gradually introduced a figurative reference, describing its "shape, color, weight," or "splitting" it into parts, before finally presenting his own shadow in "The Seasons." This human presence, however disguised, has a remarkably precious quality when compared to a good deal of Johns's earliest subject matter. In the late 1950s and 1960s he depended on "things the mind already knows,"[7] which he felt free to "do something to."[8] By contrast, this recent "thing," as in the statement, has stature and importance. Addressing "the condition of a presence," Johns has modified his outlook, and he has edged toward a style in which a vulnerable yet stately humanness is evident.

Crosshatch Paintings, 1974–82

Crosshatch Paintings, 1974–82

In many ways his most beguiling and bewildering group of works, Jasper Johns's crosshatch paintings have elicited a diverse range of responses from viewers. Some are content to explore these lush abstractions for their subtlety of composition and structure, exclaiming that the artist has momentarily become a nonobjective painter. Others, especially those aware of Johns's basic concord with Marcel Duchamp's aversion to a purely retinal art,[1] have been suspicious. For instance, Barbara Rose calls the paintings "pseudo-abstractions—impersonations of an abstract style" and claims that each is a picture "of an idea, a purely intellectual construct."[2] Elsewhere, Charles Harrison and Fred Orton suggest that "something is camouflaged or hidden" in the hatches and exhort writers to discover their secret.[3] Whereas all of these claims are to some degree true, the artist himself offers one of his typically diverting stories to explain the origin of the works: "I was riding in a car, going out to the Hamptons for the weekend, when a car came in the opposite direction. It was covered with these marks, but I only saw it for a moment—then it was gone—just a brief glimpse. But I immediately thought that I would use it for my next painting."[4]

With the crosshatchings, Johns has placed himself within the primary tradition of modernism—abstraction—and its concern for the physically literal mark that asserts the primacy of the flat picture surface. One thinks, for example, of the brushwork, intensely personal in each case, of Vincent van Gogh, Edvard Munch, and Paul Cézanne,[5] and of Pablo Picasso's gouge marks borrowed from African sculpture,[6] Henri Matisse's patterning, Jackson Pollock's linear networks, Morris Louis's languid lines, and Frank Stella's pinstripes.[7] Yet, perhaps nowhere else in the modern period does the free-hand brushstroke appear quite so noncommittal. The student of Johns's work hearkens back to the color bursts in the paintings of the late 1950s and early 1960s, for the hatching is but the latest example of the artist's study of pictorial elements. More often than not, he arranges the lines in bunches of parallel gestures, closer in appearance to hatch marks than crosshatches that intersect. Nevertheless, writers and Johns himself have used the latter designation.

As opposed to the flags and targets painted at the outset of Johns's career, the systems by which the crosshatchings are organized are now his own.

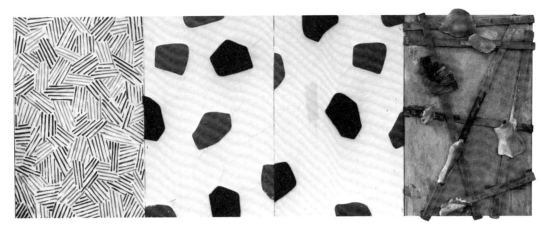

Fig. 1 *Untitled,* 1972. Oil, encaustic, and collage on canvas with objects, 72 × 192″ (182.9 × 487.7 cm). Museum Ludwig, Cologne

Much has been written about his underlying strategies; for instance, Rose analyzes a series of "moves" present in an untitled crosshatch painting that can be found in many of the others: "1) where edge meets edge, the brush-stroke may continue in the direction it began, or it may be diverted in another direction, as if refracted by the edge of the square; 2) the direction of the stroke may remain constant while it changes color; 3) both the color as well as the direction of the brushstroke may remain constant across the boundary of a square; 4) in addition, the entire content of a given square may be mirrored in an adjacent square; 5) or the square may be repositioned or 'flopped' in the way that a reproduced image can be projected or printed backward; or 6) another possibility is that the medium may change from one square to another."[8]

Johns may employ several systems to arrive at the overall composition of a crosshatch painting and each is plotted in advance. Some are based on elabo-rate patterns of repeating subsections, others are intended to suggest that the work of art could assume a continuous cylindrical form. He may, as well, utilize rules and exceptions, actions followed by reactions, or planned yet spontaneous activity. In effect, his exploration based in nonobjective art bears a likeness to events and appearances in the world,[9] but whether these exercises are intended to represent "a moral analogue—an equation of behavior in art with human behavior in general," as Rose maintains,[10] is difficult to confirm. Certainly there are lessons to be learned, or perhaps surmised, in these maneuvers—to do with chance, breadth of possibility, and

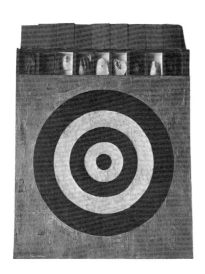

Fig. 2 *Target with Plaster Casts,* 1955. Encaustic and collage on canvas with plaster casts, 51 × 44 × 3½″ (129.5 × 111.8 × 8.9 cm). Collection Leo Castelli

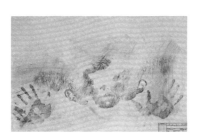

Fig. 3 *Study for Skin I,* 1962. Charcoal on drafting paper, 22 × 34″ (55.9 × 86.4 cm). Collection the artist

intense concentration. One comes to the conclusion that in Johns's crosshatch paintings, as in life itself, processes and systems almost always underlie appearances.

Johns wrote the following, probably sometime in the late 1960s:

the idea of background
(and background music)
idea of neutrality
air and the idea of air
(In breathing—in and out)

Satie's ''Furniture Music'' now
serving as background for music
as well as background for conversation.
Puns on intentions.[11]

Given the ''puns on intentions,'' it is possible, from this statement, to make certain observations about Johns's intentions. ''Background'' could refer to the convergence of a figurative back wall with a literal ground plane. Indeed, looking to contemporaneous works, one finds that in the large canvases of the late 1960s Johns depicts a quasi-illusionistic wall, then in the crosshatchings he makes the basis or support a ''ground.'' Regardless of the apparent identity of the surface, in each of these works Johns creates a neutral yet visually riveting, highly articulated arrangement of marks, not unlike the music of Erik Satie. But Johns describes that after the initial perception, Satie's music becomes ''furniture,'' a ''background'' for ''conversation.'' Likewise, Johns's crosshatch paintings may provide an armature for something akin to conversation, that is, something human. In this regard, it is useful to note that the artist's anecdote about his trip to the Hamptons concerns a decorative scheme applied to a tangible object or, conversely, an actual object that has been painted, covered, or elaborated.[12] Johns reiterated this approach elsewhere when he wrote:

Take an object
Do something to it
Do something else to it
" " " " "[13]

Thus, a primary strategy in Johns's thinking is the process of synthesizing a painterly or nonobjective mode with an actual manifestation of daily life.

Fig. 4 *Study for Skin II,* 1962. Charcoal on drafting paper, 22 × 34" (55.9 × 86.4 cm). Collection the artist

The crosshatch pattern first appeared in *Untitled,* 1972 (fig. 1), a work in four panels in which Johns attempts to make a whole out of relatively disparate parts.[14] From left to right there are crosshatch marks, flagstone patterns,[15] and casts of parts of the body, a comparison that to some extent recalls *Target with Plaster Casts,* 1955 (fig. 2). The juxtaposition between the panels in *Untitled* hints at a distinction between art and life. However, Johns pictorially subverts this idea in several ways. For instance, all of the sections are similarly based on arbitrary "rules." Each cluster of lines in the crosshatch panel can only touch the other two colors, not its own; the large flagstone shapes of the second panel have been transferred to new but corresponding positions in the third, with previously unseen ones brought into view; in the fourth the human body is taken apart and given an arrangement that is the prerogative of the artist.[16] Furthermore, Johns creates literal relationships among the four sections. A bit of purple brushstroke and the edge of a large black shape tie the first and second, the second and third are linked by a red-black form, and the third and fourth sections are joined by an imprint of an iron over the adjoining edges.[17]

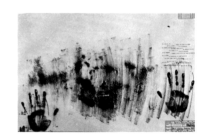

Fig. 5 *Skin with O'Hara Poem,* 1963–65. Lithograph—edition of 30, 22 × 34" (55.9 × 86.4 cm). Universal Limited Art Editions, West Islip, New York

Spatially, the sections are quite distinct from one another, although there is a kind of progression left to right. In the crosshatch panel the field is entirely flat, whereas the space in each of the flagstone sections is ambiguous, with a slight sense of layering through the imprinting of shapes.[18] The far-right panel is more illusionistic, showing a body in parts, front and back, clothed and unclothed, including apparently male and female characteristics. In this panel Johns breaks through literal space to the "things" he speaks of when he states: "As well as I can tell, I am concerned with space. With some idea

Fig. 6 *Souvenir 2*, 1964. Oil and collage on canvas with objects, 28¾ × 21″ (73 × 53.3 cm). Collection Mrs. Victor Ganz

Fig. 7 *Skin I*, 1973. Charcoal on paper, 25½ × 40¼″ (64.8 × 102.2 cm). Collection the artist

about space. And then as soon as you break space, then you have things."[19] Johns gives a sudden glimpse behind the painting, where he reveals, on a chaotic arrangement of slats,[20] the physical substance of a human life not dealt with in the relationships of abstract forms.

Johns explores a similar notion in a series of four drawings entitled *Study for Skin*, 1962 (figs. 3, 4), in which his own face and hands appear from the usually unseen side of a work of art, in essence, real life pressed up against the artistic plane from behind.[21] By the juxtaposition and title of a related lithograph, *Skin with O'Hara Poem*, 1963–65 (fig. 5), he likens an image of the human body, specifically the skin, to words that describe human content. In *Souvenir 2*, 1964 (fig. 6), Johns combines the front and back of a painting with a photograph of himself on a plate leaning against a stretcher bar. A flashlight pointing toward a rearview mirror suggests the complex apparatus that might be used to view the usually obscured stretcher side of a painting. Johns frequently exhibits an interest in looking behind, under, or above surfaces or appearances, for example, as depicted in the sculpture *High School Days*, in which a mirror on a shoe is used to look under a skirt.[22] In 1973, the year after *Untitled*, he turned again to the representation of skin in *Skin I* and *Skin II* (figs. 7, 8) but pressed his genitalia and buttocks onto the paper—in effect, the front and back of one part of his body, similar to the recto and verso of the work of art. In these works we see Johns choosing to represent the body itself from among the vehicles of human content that are available to him as a visual artist and considering the possible placement of it in relation to a picture plane.

Untitled (fig. 1) has convincingly been compared to René Magritte's *Find the Woman!* (*La Femme introuvable*) (fig. 9);[23] the flagstones are similar in both and Johns would later make explicit that the crosshatch pattern is comparable to the fingers of a hand.[24] Nevertheless, it is out of character for him simply to restate Magritte's concept. Rather, his intention may have been to construct an analogue of the human figure or presence in segments.[25] In this regard the relationships between the canvases assume great importance; while the right section can be construed as revealing the emotional state of the human being,

the flagstones, similarly floating in an open field, might be seen as the core substance of the body parts. But how is one to interpret the crosshatching?

"One thing made of another. One thing used as another" ought to be considered a basic premise of Johns's approach to art. In this passage regarding the "Skin" drawings, he continues: "*An Arrogant Object. Something to be folded or bent or stretched. (SKIN?).*"[26] Perhaps the crosshatching serves on occasion as an analogy for the outer covering of the whole figure, just as the flagstones lie under it.[27] Certainly the hatching has a similar tissuelike, membranous texture. By 1972 Johns had systematically treated almost every component of the body;[28] the material that stretches over the entire exterior can be added to this inventory of outward manifestations of the human being.[29] Besides having a place within the investigation of inherently physical states, skin coincidentally holds fascination from a painterly point of view, for it is comparable to a stretched canvas in being a surface on which marks appear. Indeed, with the likeness of skin to canvas, one may observe Johns's long-term ambition of merging the human and pictorial realms.

Fig. 8 *Skin II,* 1973. Charcoal on paper, 25½ × 40¼" (64.8 × 102.2 cm). Collection the artist

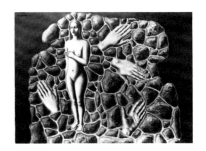

Fig. 9 René Magritte, *Find the Woman! (La Femme introuvable),* 1927 or 1928. Oil on canvas, 32 × 45½" (81.3 × 115.6 cm). Private collection

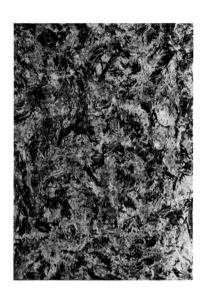

Fig. 10 Jackson Pollock, *Scent,* 1955. Oil on canvas, 78 × 57½" (198.2 × 146 cm). Collection Marcia S. Weisman, Los Angeles, California

Scent, 1973–74 (pl. 1), is the first of Johns's paintings devoted completely to the crosshatch motif. Although prefigured in *Untitled* of about two years earlier (fig. 1), the appearance of *Scent* could not be entirely expected; Johns's most ambitious work of 1973 was *Two Flags.*[30] But following his move to Stony Point, New York, in 1973, Johns turned to a nonobjective mode for the first time in his career.

Each of the three panels that make up *Scent* is quite distinct. The left section is painted in encaustic, the middle in oil without varnish on unsized canvas, and the right with varnish on sized canvas.[31] As in the earlier untitled work, there are elements that unify these differing surfaces. The flickering pattern of orange, violet, and green brushstrokes is distributed across the canvas, and an overall compositional structure is present. Thomas Hess noted that each panel is divided into three vertical subsections of about 12, 17½, and 12 inches wide and that some of these repeat in a rhythm that could be described as *a, b, c, c, d, e, e, f, a.* In other words, the left and right subsections of each panel are more or less identical with the adjacent ones, an idea first explored in the flagstone canvases of *Untitled* (fig. 1); the left and right borders of the whole painting are the same too, as if to suggest that the painting could have a cylindrical shape. By comparison, *b, d,* and *f* are unique. Hess also discovered four "secret" overlapping squares embedded in the whole (*a, b, c, c, d; b, c, c, d, e; c, d, e, e, f; d, e, e, f, a*) as well as a rectangle (*c, c, d, e, e*) in the center of the composition.[32] Thus *Scent* consists of an organization of marks in which each cluster belongs to a genus determined by a structure or medium. Although some are part of unique entities, all systems interlock. Johns started with this plan, much as earlier in his career the patterns of flags or targets were the beginning point for a painting. Armed with a "map" of actions to be taken, he could then revel in the process of making.

Although Johns insists that he was not seeking an intentional play on Jackson Pollock's *Scent* (fig. 10) and even considered renaming the work when he realized the coincidence,[33] the comparison is provocative. *Scent,* Johns's first completely abstract image, bears a similarity to the Abstract Expressionist's all-over composition, rich with visual incident, but Johns's painting is lean,

1
Scent
1973–74
Oil and encaustic on canvas (three panels)
72 × 126¼" (183 × 321 cm)
Bayerische Staatsgemäldesammlungen,
Staatsgalerie moderner Kunst, Munich.
Lent by Prof. Peter and Irene Ludwig

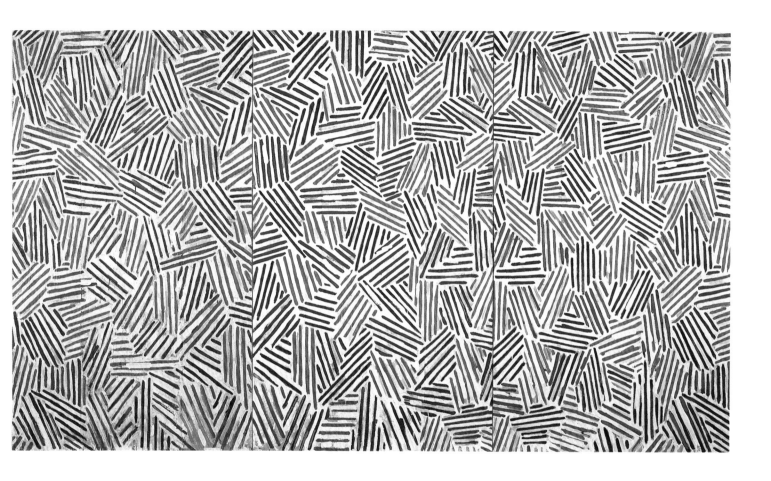

Fig. 11 *Map* (based on Buckminster Fuller's Dymaxion Airocean World), 1967–71. Encaustic and collage on canvas, 186 × 396″ (472.4 × 1005.8 cm). Museum Ludwig, Cologne

airy, and ordered.[34] Indeed one might speak of him giving structure and permanence to Pollock as Cézanne had given to the Impressionists.[35] But whereas paintings by Pollock suggest a sense of infinite space, Johns's cylindrical composition brings Abstract Expressionism back to earth. Likewise in *Map,* 1967–71 (fig. 11), Johns depicts the finite form of a continuous orb on a flat plane; in this task his actions were naturally predetermined, as in *Scent* to some extent and as opposed to Pollock's more improvisational style.

The only literal fragrance of *Scent* is the paint medium itself. Yet the title suggests the presence of something masked in the lush brushstrokes, perhaps the structure that is hidden but sensed, as if a characteristic smell. Ironically that scent will be discovered not by the nostrils but by the eyes. Working with the sense of sight, the mind, too, can indulge in the process of determining the source of the scent. In this regard, a six-foot-high cylindrical shape may, with some imagination, be linked to the body of a standing figure, an association that is enhanced by Johns's consideration of the subject of skin. Although he might otherwise be reluctant to suggest anything beyond what is literally given or literally implied, by giving *Scent* its title, Johns directs the viewer elsewhere, suggesting that the marks may in fact mean something.

Having established the pictorial mode of the crosshatch, Johns immediately utilized it within his familiar framework of the double image in *Corpse and Mirror,* 1974 (pl. 2).[36] His use of the double or mirror image dates from as early as 1959,[37] and in his writings he observes:

We say one thing is not another thing.
Or sometimes we say it is.
Or we say "they are the same."[38]

The artist's, and subsequently the viewer's, inquiry has to do with a process of identification, about which Johns recalls the words of Marcel Duchamp:

lose the possibility of identifying . . .
2 colors, 2 laces, 2 hats, 2 forms
to reach the
Impossibility of sufficient visual memory
to transfer from one like object
to another the memory imprint.[39]

As with Johns's paintings of flags and maps and sculpted ale cans, *Corpse and Mirror* requires the viewer's close inspection to discern differences between apparently like entities. His usual practice in the double-image paintings is to juxtapose the more "correct" or conventional rendering, painted in oil, on the left side and an altered version on the right, in encaustic, as if following the rule of right reading. The comparisons establish an exemplar and an exception, similar to the pattern of duplications and unique passages in *Scent* (pl. 1).[40] The double stimulates other observations too; for example, there is the image or thing presented in an apparently deadpan manner, and that entity observed, recorded, replicated, or acted upon. And there is the Johnsian question, "Whether to see the 2 parts as one thing or as two things."[41]

On the left side of *Corpse and Mirror,* in oil, Johns divides the canvas into three horizontal subsections separated by distinct grooves in the paint surface. It is impossible to know where his painted actions might have started,

2
Corpse and Mirror
1974
Oil, encaustic, and collage on canvas (two
panels)
50 × 68½″ (127 × 174 cm)
Collection Mrs. Victor Ganz

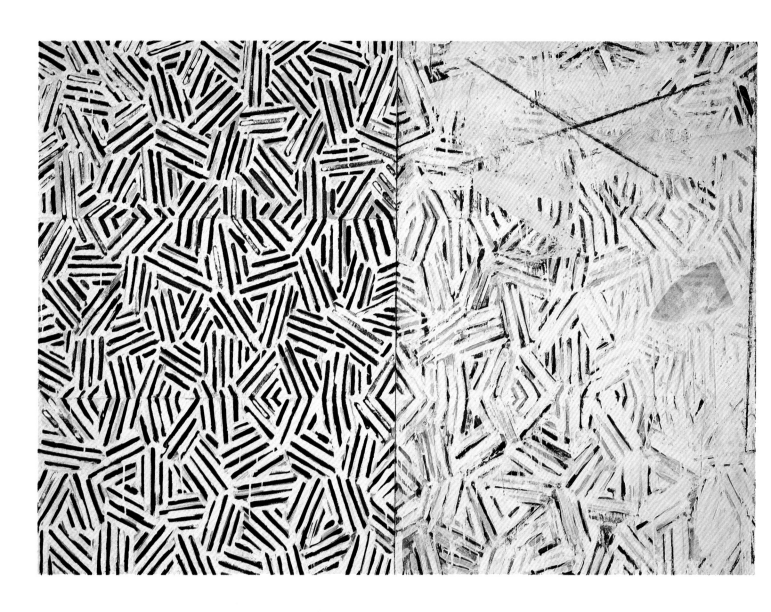

but the outcome is a composition in which the lines of each subsection systematically cross into the next. This mode is essentially the same as the one followed by the Surrealists in making what they called an exquisite corpse, with several artists and poets contributing to a single work, each starting with just an edge of what had been drawn by the previous person.[42] Across the vertical division, on a second canvas, Johns paints a mirror image of the left half of the painting in encaustic paint.[43]

In a different medium, reversed, and with the newsprint underneath revealed, the image on the right proclaims its uniqueness. Like the juxtaposition in *4 the News* (fig. 12), the hatches set forth a placid, seamless demeanor, whereas the introduction of newsprint—regardless of headline[44]—suggests feelings and content. In this regard, Johns wrote:

Think of the edge of the city and the traffic there. Some clear souvenir—A photograph (A newspaper clipping caught in the frame of the mirror).[45]

Thus, the diptych format in *Corpse and Mirror* imparts a divided state of being; compared to the "perfect," serene left side, the mirrored image has a residue left from the world of events, imbuing it with a degree of vulnerability.

In contrast to the left half, the right side of *Corpse and Mirror* is an arena of exaggerated actions and interruptions. In effect the former is a given and the latter a contradiction. The most obvious signs of this response, besides the newsprint that "mars" the surface established on the left, are the large *X* form, vertical slash mark along the right edge, imprint of an iron, and gray and beige areas of encaustic that blot out extensive sections of the black and white pattern. The shadowy footprintlike iron, similar to many objects depicted by Johns, is a tool of the artist, used in the process of encaustic painting. Whereas the iron is apparently traced, the *X* is a drawn mark, yet both seem to hover just above the surface of the paint film and are like smudges that betray the mirror's identity and abrogate the sense of illusion.[46] The *X*, a powerful form of negation,[47] embodies a kind of instinctive reaction to the visual assertion and flow of crosshatches on the left. Indeed Johns often

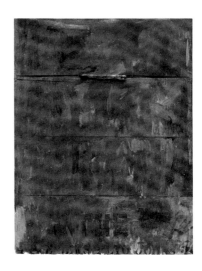

Fig. 12 *4 the News,* 1962. Encaustic and collage on canvas with objects, 65 × 50¼" (165.1 × 127.6 cm). Kunstsammlung Nordrhein-Westfalen, Düsseldorf

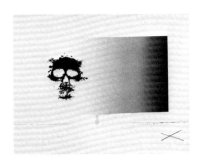

Fig. 13 *Untitled (Skull)* from the portfolio *Reality and Paradoxes,* 1973. Silkscreen— edition of 100 (AP 8/25), 24 × 33″ (61 × 83.8 cm). Multiples, Inc. Collection the artist

refers to this emotionally charged situation: "My work became a constant negation of impulses."[48] Elsewhere he states: "At times I will attempt to do something which seems quite uncalled for in the painting, so that the work won't proceed so logically from where it is, but will go somewhere else."[49]

An *X* is a mark used by printmakers to signify cancellation,[50] and Johns had made prominent use of it during the preceding year in an untitled silkscreen from a portfolio called *Reality and Paradoxes* (fig. 13). Comparison of the latter title and image with *Corpse and Mirror* suggests rich levels of meaning for the painting.[51] If we identify the left half as the "corpse,"[52] it is, like the skull in the silkscreen, an absolute, unambiguous, whole "fact." Compared to this apparently straightforward reference, there is a range of paradoxical notions concentrated in the word "mirror" and in this mirrored image,[53] with its incongruities and negations indicative of life. A decade earlier, Johns had explored some of the same content in *Souvenir 2* (fig. 6); there a memory of life—the photograph—is juxtaposed with an object—the mirror—which upon being looked at reflects a living individual. Both the photograph and the mirror may be said to exhibit life at different stages.

In contrast to *Scent* (pl. 1), which possesses that quality of neutral background music discussed earlier and requires the viewer's analytical faculties of detection, *Corpse and Mirror* evokes a yet more complex response. Moody and passive-aggressive in its abstract strategies, the painting has a rich mélange of meanings indicative of our having passed from the "scent" of an individual to some darker aspects of life experience.

Many more layers and varieties of gestural crosshatching and brushstrokes animate the encaustic surface of *Weeping Women,* 1975 (pl. 3). Red, yellow, or blue in overall tonality, each panel has some slight indication of the forms in the other two sections, but only the triangular shape in the upper section is clearly repeated in all three.[54] Linking the three canvases are an alternately blurry and clearly drawn horizontal streak at the bottom and the newsprint that appears throughout.

In his development from *Scent* (pl. 1) through *Corpse and Mirror* (pl. 2) and *Dutch Wives* (fig. 14) to *Weeping Women,* Johns has seemingly sought to present aspects or variants of a, sometimes female, human presence. The titles allude to a bodily fragrance, a body and its reflection, surrogates of women's bodies (so-called Dutch wives), and grief. But pictorially *Scent* and *Corpse and Mirror* are essentially nonobjective, whereas the latter two are more suggestive; Johns depicts a surrogate vagina in *Dutch Wives* and indicates abstracted figures in *Weeping Women.* In the latter painting the imprints made from an iron and the circles from a tin can are like the parts of a body pressed against paper in the skin drawings (figs. 3, 4, 7, 8), as if a figure is trapped within the webbing of *Weeping Women* trying to be seen. Specifically, a figure seems to be integrated with the crosshatch pattern (at the left), to lie over the markings (in the center), or to press up against the canvas from behind (at the right), although each phenomenon is not exclusive to a panel. Helping to articulate the abstracted figures is the use of white, a variation on a technique present in early Cubist paintings and elsewhere to define details of a figure as they emerge from the background.

The figure in the center of *Weeping Women* has aptly been compared to Picasso's proto-Cubist renderings of 1907–9;[55] indeed the triangular shapes in the upper corners resemble the familiar upreaching arm, bent at the elbow and folded back behind the head, which is also seen in the work of Cézanne. The iron imprints add further complexity to the depiction, for the horizontally directed ones could be thought of as arms or breasts, and the downturned irons as legs, hands, or teardrops. Because of this multiplicity of aspects, the figure may also be compared to Leonardo's well-known *Study in Human*

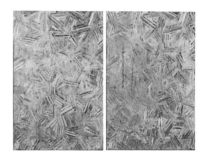

Fig. 14 *The Dutch Wives,* 1975. Encaustic and collage on canvas, 51¾ × 71″ (131.4 × 180.3 cm). Collection the artist

3
Weeping Women
1975
Encaustic and collage on canvas (three
panels)
50 × 102¼" (127 × 260 cm)
Collection Mr. and Mrs. S. I. Newhouse,
Jr., New York

Proportions According to Vitruvius (Accademia, Venice) in which arms and legs reach out toward the perimeter of the circle; the ambiguous disposition of the figure also recalls Johns's interest in "Leonardo's idea . . . that the boundary of a body is neither a part of the enclosed body nor a part of the surrounding atmosphere,"[56] itself an altogether Cubist-like notion. There is a certain "iron-y" in the labeling of the imprints, as Johns subsumes all meanings for the word; indeed the iron called to mind linguistically was literally used to apply the encaustic onto the surface of the painting. During work on *Weeping Women* Johns thought about and enjoyed the coincidence of yet another reference to the iron in Degas's many depictions of laundresses.[57]

In the blue panel of *Weeping Women* the figure is suggested, in part, by a pair of circular imprints, which could be considered the breasts of a woman or the teary eyes of a large head. The circle has a rich history in Johns's work;[58] for instance, in *Dutch Wives* the circle signifies a hole in a wooden plank through which the user masturbates and the spot, his ejaculation. Johns seems to revel in this accumulation of association and in the possibility that the circular form, such as the iron, has the capacity to assume many identities, all the better to unsettle the viewer seeking a secure interpretation.

The title *Weeping Women* refers to Picasso's series of paintings, drawings, and prints entitled *Weeping Woman*.[59] However, the composition could be compared to *The Three Dancers*, 1925, by Picasso (fig. 15), in that flanking a symmetrical central figure may be abstracted versions of his dancer-mourners. In this regard, the fact that a triptych entitled *Weeping Women* follows shortly after *Corpse and Mirror* suggests that Johns was pondering death and earlier representations of a crucifixion, both of which are attended by mourning. That weeping theoretically might be heard in a painting calls to mind such Johnsian notions as a voice perceived or a scent detected in a canvas.

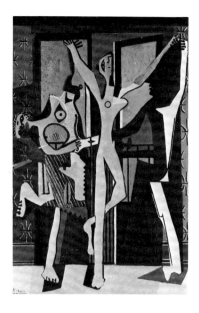

Fig. 15 Pablo Picasso, *The Three Dancers,* 1925. Oil on canvas, 84¾ × 56″ (215.3 × 142.2 cm). The Tate Gallery, London

While Johns was at work at the print workshop Universal Limited Art Editions (ULAE) in Long Island, its proprietor, Tatyana Grosman, commented that some of his images reminded her of the writings of Samuel Beckett. Shortly thereafter, quite coincidentally, Johns was approached about a project to collaborate with the author.[60] At the time, the imagery of *Untitled* (fig. 1) dominated his lithographic production, and he felt that this material could be useful: "This is what I should do for Beckett because I won't ever have anything that will be more appropriate."[61] What followed was not truly a collaboration, however. After declining to work with previously published texts, Johns received five unpublished manuscripts from which he was then to construct a book in 1975–76 (pl. 4).[62] Johns considered the volume an object in literal terms, taking the alternating French-English texts as a model. Mimicking these he created mirror images, reflections, echoes, and visual composites to unite the pages. The whole is organized into five sections, each introduced by a numeral. Johns and Beckett are complementary in their explicit and implicit pessimism and preoccupation with physical debilitations.[63] In the first section Beckett presents the idea of an outer and inner self, the latter having the potential to outlive the pathetically human body. Subsequently, the protagonist must constantly grope in the dark to find his bearings, and there are frequent references to body parts. Johns, too, in his imagery for *Fizzles,* takes a literal view of the human being, his body and his condition.

Upon completion of the book, Johns created a painting that clearly relates to it called *End Paper,* 1976 (pl. 5). Unlike the actual endpapers in *Foirades/Fizzles,* which repeat the same type of pattern, Johns follows the double-spread image in the third section, juxtaposing two patterns. Joined as they are, the halves present a relationship of apparently disparate yet forever linked entities.[64] The title refers not only to that part of a book but also to Beckett's play *Endgame.*[65] In it Beckett creates characters who sardonically endure life and mock their constant unhappiness. The walls of the room they inhabit are reminders that no exit is possible from this claustrophobic existence nor can air or light be admitted into the interior. Similarly, Johns himself was much interested in the confining limits of floors and walls, and each half of *End Paper* has an opaque identity.[66]

4
Foirades / Fizzles
1975–76
Published by Petersburg Press
33 etchings and 1 lithograph, bound
13 × 10″ (33 × 25 cm)
Collection Morris L. and Mildred L.
Weisberg, Philadelphia
Unbound pages lent by Petersburg Press

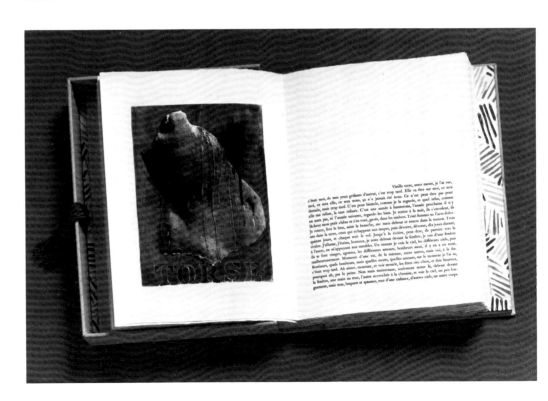

5
End Paper
1976
Oil on canvas (two panels)
60 × 69½″ (152 × 177 cm)
Collection Philip Johnson

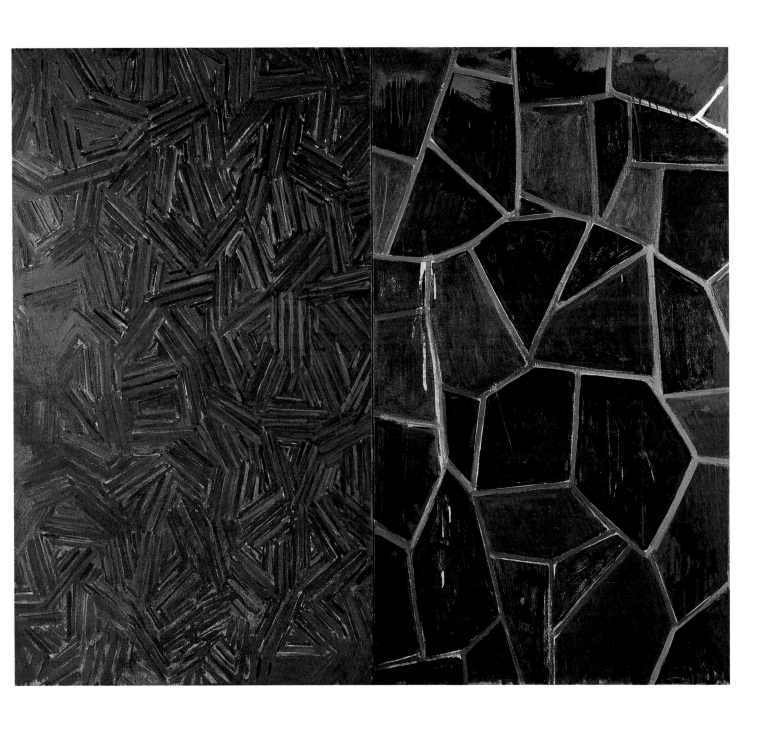

Usuyuki, 1977–78 (pl. 6), consists of three canvases that are framed together as a triptych but separated by wooden strips. Johns explains that the overall hatch pattern is predetermined and based on a plan of repeating subsections (fig. 16); the arrangement of imprints on the canvas is also preassigned. By this composition, Johns wants to create a two-dimensional approximation of the appearance of two systems of marks, on a donut-shaped object, as each spirals in opposite directions.[67] One recalls here his interest in "the rotating point of view" of Cézanne and Cubism,[68] except that Johns's intention is based on a stationary viewpoint from which to witness a painted, quickly moving object.

Usuyuki is the first of a number of works by this title in which Johns returns to that seemingly harmonious, airy state that was present in *Scent* (pl. 1). "Usuyuki" is a Japanese word meaning thin or light snow;[69] indeed, Johns's luminously spare work, painted entirely in flesh colors,[70] has a fleeting sense about it. Johns and his friend the composer John Cage share a great enthusiasm for Asia and Asian thought, in which is explored an interest in a kind of serene nothingness (no beginning, middle, or end). Quoting a passage in the *I-Ching,* the ancient Chinese book of divination, Cage records the following description that could be applied to *Usuyuki:*

Tranquil beauty: clarity within, quiet without.
This is the tran-quillity of pure
contemplation. When desire is silenced and the will comes to rest
the world as i-dea becomes manifest. In this
aspect the world is beautiful
and re-moved from the struggle for existence. This is the world of Art.[71]

But this evocation of infinity, like the new snow, may pass quickly. "Usuyuki" is also the name of a Japanese kabuki play with a complicated plot, and Johns thickens his own painted scenario by means of the variously sized circles distributed irregularly in the composition. These, and the curious imprint at the upper right reminiscent of Duchamp's *Female Fig Leaf,*[72] are "events" in the tranquil world of the crosshatches or "footprints in the snow." Vivid entities

6
Usuyuki
1977–78
Encaustic and collage on canvas (three
panels)
35⅛ × 56⅝″ (89 × 144 cm)
Collection the artist

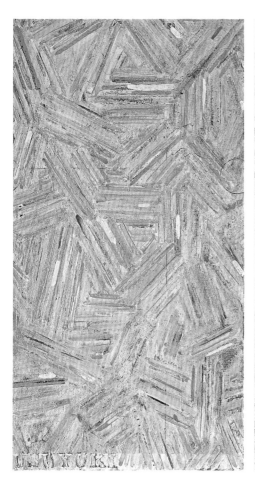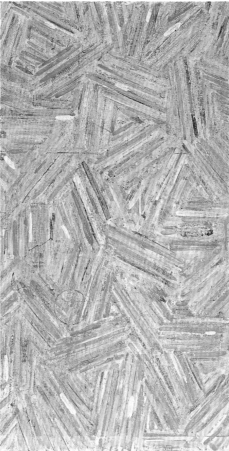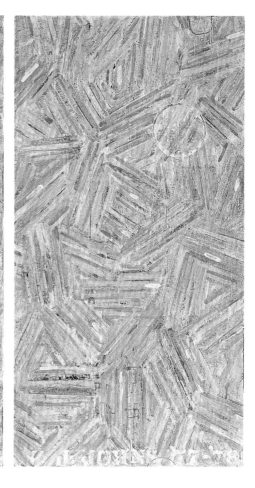

compared to the overall seamlessness of the composition, the circles and quixotic imprint may, given Johns's earlier practices, be interpreted as symbolic of sexual organs.

Each circle has the impact of an *X* that marks a spot, yet the form should also be understood as encircling and magnifying in importance a location in the painting. A similar but literary metaphor exists in the poem "Cape Hatteras" by Hart Crane, a favorite writer of Johns.[73] The poet establishes a sense of infinite sea, sky, and space, which is searched by various explorers, flyers, poets, and birds. All the vehicles of sight described by Crane, including the eye, periscope, and searchlight, are circular in form. When focused and effective, these may bring forth a "crucible of endless space" or "splintered space";[74] in other words, Crane describes taking the measure of something that is apparently limitless. Well known for his own measuring devices, Johns uses the circle to examine the seemingly limitless crosshatch surface of his own making.

Fig. 16 Plan and diagram of *Usuyuki*

M	N	O
J	K	L
G	H	I
D	E	F
A	B	C

Plan of *Usuyuki*

G	H	I	L	J	K	N	O	M
D	E	F	I	G	H	K	L	J
A	B	C	F	D	E	H	I	G

Diagram of *Usuyuki*

Johns employs the pattern seen in the right portion of *End Paper* (pl. 5) for the lower right quadrant of *Céline,* 1978 (pl. 7), but reconfigures the earlier composition by making a prominent horizontal division. The upper and lower sections are themselves vertically halved; however, these latter subsections do not precisely line up together. Johns has created a mirror effect between the left edge of each upper subsection, based on corresponding left and right hand prints; furthermore, the pattern on the inside edges of the lower subsections repeats. If the subsections in each half of the painting were overlapped so as to eliminate one of the repeats or mirrored hand-print areas, then the resulting horizontal dimensions would equal the vertical ones to form a pair of squares. Further complicating the composition, certain lines create continuity between the dissimilar but vertically contiguous quarters. Given the intermingling of types, one is reminded of the following statements by Johns: "Most of my thoughts involve impurities," and "I think it is a form of play, or a form of exercise, and it's in part mental and in part visual (and God knows what that is) but that's one of the things we like about the visual arts. The terms in which we're accustomed to thinking are adulterated or abused."[75] Johns's composition has a disturbed quality; once whole and precise, the seemingly distinct parts have been divided and dislocated, some even invading one another. In response, the viewer may attempt to reassemble the parts visually.

If the lower section has a certain impassive atmosphere, like a wall with just a few marks on it, the upper section shows evidence of much intervention. The hand print,[76] a finger-painting gesture, offers a more direct and impulsive imprint than the means by which the flagstone pattern and the overlaying bunches of regular lines might have been painted. But the hand print is emotive as well and echoes the gesture Johns had employed to refer to the suicide by drowning of the poet Hart Crane.

Naming the painting for the French novelist Louis-Ferdinand Céline, Johns arms the viewer, on this rare occasion, with an explicit clue about the nature of his outlook and source of inspiration. Céline's writings exude an overwhelming cynicism and preoccupation with death, qualities that may be found on occasion in Johns's work as well; also, both artists exhibit a fondness for

7
Céline
1978
Oil on canvas (two panels)
85⅝ × 48¾″ (217.5 × 124 cm)
Kunstmuseum Basel

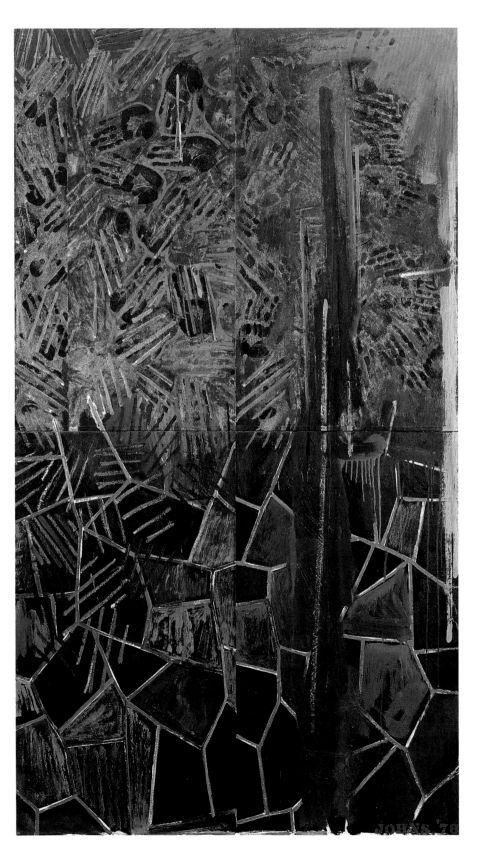

negation and human imperfections.[77] The frantic hand prints in *Céline* suggest, for example, the spirit of the writer's *Journey to the End of Night,* wherein death is pervasive.[78] One might compare the following passage to the painting:

Over our heads, . . . maybe one millimeter from our temples, those long tempting lines of steel, that bullets make when they're out to kill you, were whistling through the summer air.

I'd never felt so useless as I did amid all those bullets in the sunshine. A vast and universal mockery.[79]

Céline, with its desperate mood and "adulterated" patterns, is rare in the stream of crosshatch works and signals a change in direction for Johns that would not come fully to the fore until 1982.

In 1979 Johns invoked the name of an insect for his crosshatching in water-color on a drafting film support (pl. 8).[80] With this title, he alludes to the cicada's well-known vibrating sound, again as if the two-dimensional work of art could possess a voice. Johns enjoys the fact, too, that a cicada, upon birth, contains another version of itself within its shell, that the insect starts life in a lobsterlike form and then becomes winged.[81] "My experience of life," Johns related, "is that it's very fragmented. In one place, certain kinds of things occur, and in another place, a different kind of thing occurs. I would like my work to have some vivid indication of those differences. I guess, in painting, it would amount to different kinds of space being represented in it."[82]

Whereas the nonreferential, flat crosshatch pattern might offer a serene notion of life, the unusual section below, like a predella, exhibits "a different kind of thing." There, as if in a diary of disjointed notations, Johns admits the intrusion of three-dimensional, anecdotal existence, with cicadas, skulls, a flaming boat,[83] numerous renderings of testicles and phallic shapes, what looks like a spigot handle, and the words POPE PRAYS AT AUSCHWITZ / "Only Peace!"[84] By counterbalancing his crosshatch in this way, Johns recalls *Untitled* (fig. 1), the combination of body casts with a target at the beginning of his career (fig. 2), or the rendering of a red arm beneath a Savarin can filled with brushes in a print of 1982.[85] It is not enough, however, to speak of this fundamental juxtaposition as distinguishing between art and life. In effect, Johns integrates into one work a facade with what lies behind, an abstract image with its potential human content, and the beautiful with the horrific. All are aspects of one entity.

8
Cicada
1979
Watercolor and pencil on paper
38½ × 28″ (98 × 71 cm)
Collection the artist

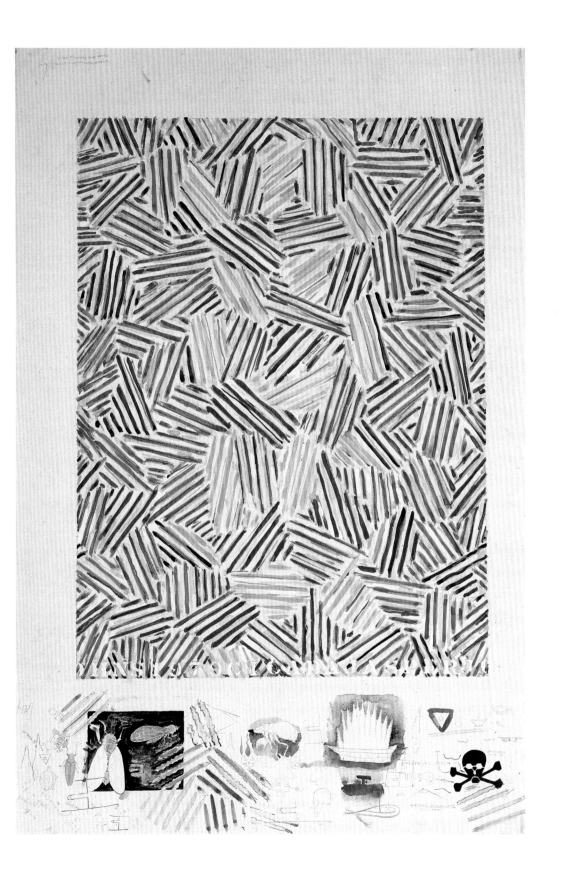

The finely tuned composition of *Dancers on a Plane,* 1979 (pl. 9), consists of mirrored vertical halves, each of which is divided horizontally into four sub-sections. Johns always makes certain to show the bundle of hatches of one color surrounded by the other two primary colors;[86] at the crucial horizontal borders, he continues the hatch lines in some fashion, as in the game exquisite corpse, but alters either the color or the direction of the mark or both. Although these rules prevail, there is much freedom for idiosyncracy.

The rhythmic character of the crosshatch pattern is complemented on the vertical borders where white-painted metal eating utensils provide a counterpoint or base line. There is a clear and repeating pattern in which the knives are mirrored and a fork is always opposite a spoon. A corollary system can be discerned as well, starting at each upper corner, reading down, and continuing upward to the opposite corner. Knife, spoon, fork, and so forth, is one; knife, fork, spoon is the other.

The letters of the title, in primary colors, and of the painter's name and date of the work, in white, are interwoven across the bottom. Divided into the same number of red, white, blue, and yellow elements on each side, the arrangement of letters is highlighted by the symmetrical *A* in the middle. Cut off at each end, the row suggests the familiar cylindrical composition that the whole painting assumes.

The only imperfect, or completely unaccounted for, element is the black slash at the far right, accompanied by bits of the same color nearby, which are not precisely duplicated on the left. As in *Corpse and Mirror* (pl. 2) the right side is thus distinguished as being the mirrored one.

Johns made a second *Dancers on a Plane* in 1980 (pl. 10), in which the cross-hatch pattern and arrangement of utensils (now cast in bronze by the artist) appear to follow the rule established in the first painting. However, the coloration is altogether different, and large patches of the right side are painted over. After the even, buoyant disposition of the first painting, Johns

9
Dancers on a Plane
1979
Oil on canvas with objects
77⅞ × 64″ (197.5 × 162.5 cm)
Collection the artist

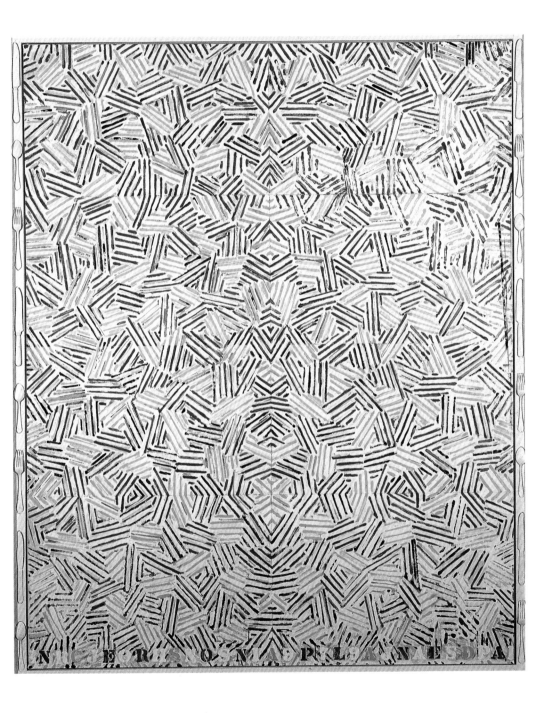

wanted to emphasize certain sections.[87] The dotted vertical line was borrowed from an illustration he had seen of Tantric jewelry consisting of garlands of skulls.[88] Besides being equal to half the width of the canvas, the line signals the symmetrical composition of the vertical halves and divides the canvas at mirror point. Still, the line is unique in the composition, an exception to the all-over pattern of the crosshatching.

At the bottom of the ominous sequel Johns intersperses the letters of the name of Merce Cunningham with mirrored letters of the title, in effect equating one with the other. The combination creates the sense, too, that the painting could be viewed from the front and back,[89] not unlike the phenomenon described earlier in the skin drawings (figs. 3, 4, 7, 8), of being able to see the outward surface and what, or who, lies behind the painting. Further influenced by "Tantric paintings in which Shiva and Shakti copulate, representing the interpenetration of destructive and creative forces,"[90] Johns added testicles and part of a phallus to the lower border, and the continuation of the penis at the top edge.[91] These aspects, along with the symmetrical composition, create the sense of a fragmented and abstracted human presence, perhaps the dancer in the title lying over the plane of the painting. In this view the utensils are like the multiple arms and legs of a gyrating figure of Shiva.

The title *Dancers on a Plane* reaffirms Johns's tendency to add a figurative, three-dimensional presence to his flat, two-dimensional surface and also subsumes a long-standing interest to intermingle several art forms and sensory experiences. By naming two works *Dancers on a Plane* Johns likens his sequence of marks in the crosshatch works to the actions of the dancer, along with the sounds of the musician,[92] while the words add a literary dimension as well.

Johns had made use of household utensils for a number of years, in part motivated by the following thoughts: "My thinking is perhaps dependent on real things. . . . I'm not willing to accept the representation of a thing as being the real thing, and I am frequently unwilling to work with the representation of the thing as . . . standing for the real thing. I like what I see to be real, or to be

10
Dancers on a Plane
1980
Oil on canvas with painted bronze frame
and objects
78⅜ × 63¾″ (200 × 162 cm)
The Tate Gallery, London

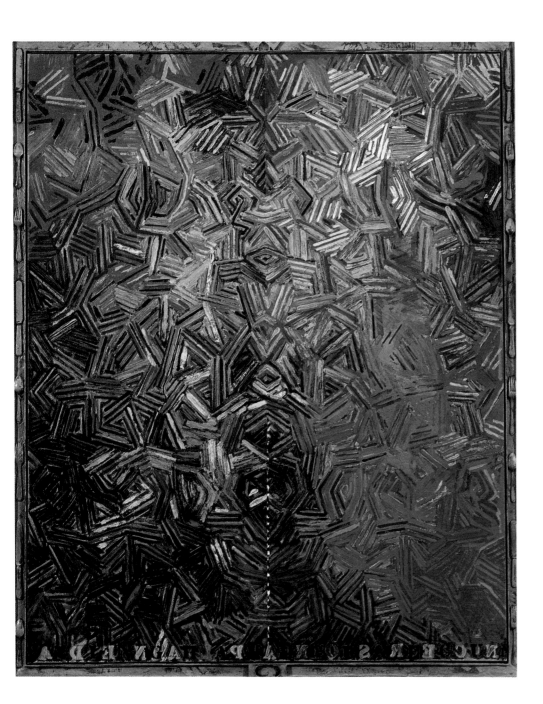

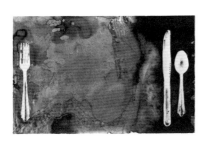

Fig. 17 *Study for "In Memory of My Feelings,"* 1967. Ink and pencil on plastic, 11 × 7³⁄₁₆″ (27.9 × 17.8 cm). Collection the artist

my idea of what is real. And I think I have a kind of resentment against illusion when I can recognize it. Also, a large part of my work has been involved with the painting as object, as real thing in itself. And in the face of that 'tragedy,' so far, my general development . . . has moved in the direction of using real things as painting. That is to say I find it more interesting to use a real fork as painting than it is to use painting as a real fork."[93]

Even while juxtaposing an aesthetic two-dimensional plane with a three-dimensional space at the edge, Johns equates the two fields as he had done in *Cicada* (pl. 8) by showing that both the canvas and the utensils are objects he has covered with paint. With this comparison, the painting may be considered a real thing.

Notwithstanding the formal use of the utensils or the identification with the limbs of the dancer there is much to indicate a layering of thematic associations as well. For instance, the sexual references in Johns's work[94] and the presence of genitalia in the 1980 *Dancers on a Plane* suggest that the utensils might be understood in a similar way, that is, the knife and fork are rigid, stabbing forms and the spoon is receptaclelike in function.[95] Furthermore, Johns has made another association through the context of eating food:

The watchman falls into the trap of looking. The spy is a different person. Looking is and is not eating and being eaten.[96]

In other words, the watchman/viewer eats or consumes the work of art, presumably with eating utensils; in this ambiguous situation, the spy/artist is both a victim of the meal as well as the perpetrator of an elaborate deceit. Thus Johns places his image on a plate in *Souvenir 2* (fig. 6), but when illustrating a poem by his friend Frank O'Hara for a memorial volume, he creates a table setting that lacks a plate (fig. 17), indicating the loss of the artist-object. As if to further entangle these references, Johns says "my work feeds upon itself."[97]

The potential sources for the utensils are many,[98] but one that may be especially important for Johns is a statement by John Cage. In an imaginary conversation with Erik Satie, which must have served as the model for Johns's comment quoted earlier,[99] the composer writes: "Nevertheless, we must bring about a music which is like furniture—a music, that is, which will be part of the noises of the environment, will take them into consideration. I think of it as melodious, softening the noises of the knives and forks, not dominating them, not imposing itself."[100] In a sense, Cage's description parallels Johns's notion of the dichotomy between the watchman and the spy, as the former becomes the wielder of eating utensils whereas the latter is the creator of the music. Still, it is necessary for the composer to include the ambient noise of the audience rather than build walls between the work of art and the environment. Johns's inclusion of the utensils acknowledges such an approach and suggests that the painting will be orally consumed. It is even possible to proceed to an interpretation of the paintings in narrative and in anthropomorphic terms: the lively performance of the painter-dancer-musician-writer on a flat, multivalent plane is watched by the still observers seated in neat rows, along the right and left edges.

Fig. 18 Paul Cézanne, *Young Man with a Skull,* 1896–98. Oil on canvas, 51⅛ × 38½" (130 × 97 cm). © The Barnes Foundation, Merion, Pennsylvania

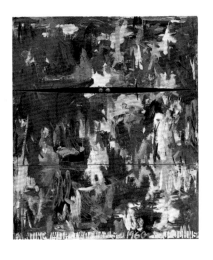

Fig. 19 *Painting with Two Balls,* 1960. Encaustic and collage on canvas with objects, 65 × 54" (165.1 × 137.2 cm). Collection the artist

Johns expands on *Cicada* (pl. 8) and the second *Dancers on a Plane* (pl. 10) by integrating an image of a skull and testicles with a crosshatch pattern in *Tantric Detail,* 1980 (pl. 11).[101] While the length of the dotted line has no link here to the dimensions of the painting, by dividing the canvas, it evokes the symmetrical pattern of the human physique and the body parts that are shown. It contributes, too, in defining the central juxtaposition, for the skull is held or pulled toward the earth by the line, whereas the genitalia are moving upward. In keeping with Johns's usual approach, a quite literal understanding of the disposition of these bodyparts is possible. The drawing may be viewed as vertically continuous; the fragmented figure of displaced parts can be read in "correct" alignment by conceiving of the testicles brought around to exist below the skull or vice versa. Hence, Johns creates a disjunctive body in which the elements, in effect, belong to one entity. The hatching is like the skin, however flayed or irregular, of this contorted, yet exquisite, corpse.

Johns sets forth the two principal *nature morte* motifs as equally powerful symbols of life and death, eros and mortality, and with the title relates the theme to Tantric literature, in which Buddhists meditate deeply on the connections between sexuality and death.[102] However, he had himself used the skull often in his art and especially admires Cézanne's *Young Man with a Skull* (fig. 18). Early in his career he wrote:

A Dead Man.
Take a skull.
Cover it with paint. Rub it
against canvas. Skull against
canvas.[103]

His use of testicles recalls *Painting with Two Balls,* 1960 (fig. 19). Indeed both works exhibit a flat, more or less continuous, pattern of marks, divided horizontally into three equal sections, within which an "event" occurs. Here, after two decades, Johns makes the slang expression "two balls" explicit.

11
Tantric Detail
1980
Charcoal on paper
50½ × 34½″ (128 × 88 cm)
Collection the artist

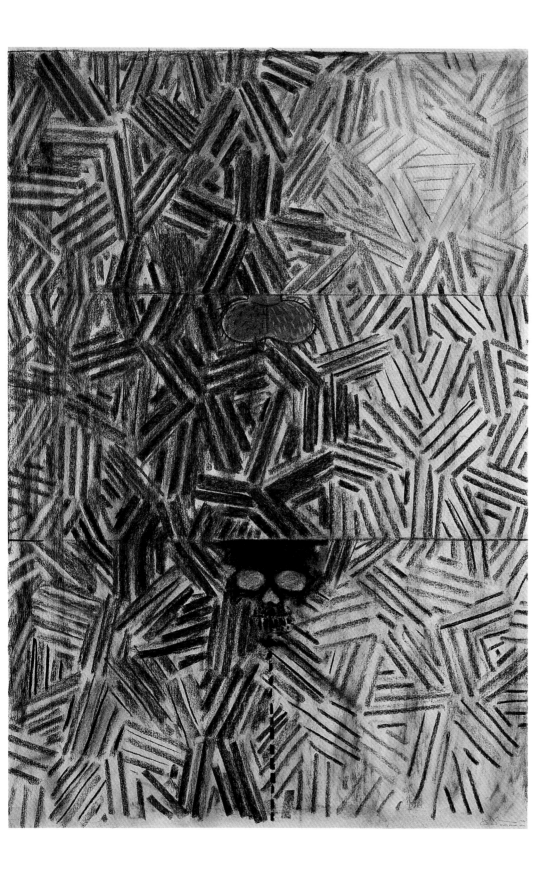

The system at work in the series of three paintings entitled *Between the Clock and the Bed* (pls. 12–14) concerns the distinctions between unique and repeating patterns. In each work the left and right panels mirror one another and if brought together would form a rectangle consisting of a symmetrical, reflecting composition. The central section of each triptych is distinguished from its surroundings; however, at the edges of the middle section, the lines continue into the adjoining panels, thereby sharing traits with the flanking patterns. The far-left and right edges match up to suggest the familiar cylindrical composition.

Johns recalls that the first (pl. 12), in encaustic, preceded the second (pl. 13), in oil, during 1981,[104] but the two paintings are very close in appearance. The positions of the left and right panels of the first are reversed in the second work while the tonalities are virtually the same. In the third of the series, painted in 1982–83 (pl. 14), again in encaustic, Johns employed a palette of gray, black, and white, creating a friezelike effect by the resulting light-dark rhythm. In this last painting the patterns of the left and right sides closely repeat the second of the series, as does the center, except that it is in reversed format. Johns's approach is like that of a poet enraptured with the sonnet; he meditates on his given structure, finding ways to create subtle variations in form, mood, and color. Indeed the three works entitled *Between the Clock and the Bed* might be considered a suite of rhapsodic elegies to the crosshatch. Although a system is applied, these are reveries founded on the activity of the artist manipulating paint on a canvas surface.

In the second painting of the series, Johns multiplied the triptych idea by silk-screening onto the canvas an image of his *Usuyuki* print of 1979.[105] As in *4 the News* (fig. 12), the added element is a sort of intrusion from the real world, in this case replete with fragments of newsprint items that can be construed, because of the context, as Cubist-style in jokes about the process of making art, replication, and perception. Among the notable phrases repeated in all three sections are "[F]alsehoods and Distortions," "An Illusion of Educat[ion]," "John (Johnny Dio) Dioguard"; "Prof. Nutter" is mentioned prominently throughout. Adding yet another layer to the overlay of planes are the circles in each of the three sections of the *Usuyuki* image.

12
Between the Clock and the Bed
1981
Encaustic on canvas (three panels)
72 × 126¼″ (183 × 321 cm)
The Museum of Modern Art, New York
Gift of Agnes Gund

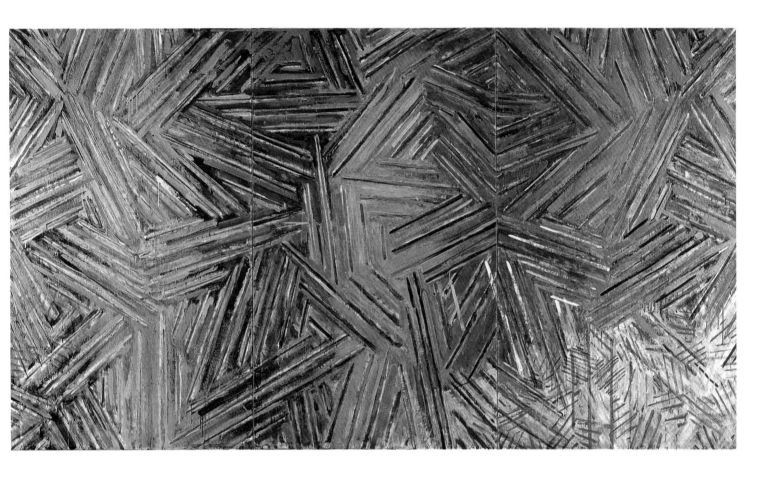

13
Between the Clock and the Bed
1981
Oil on canvas (three panels)
72 × 126¼″ (183 × 321 cm)
Collection the artist

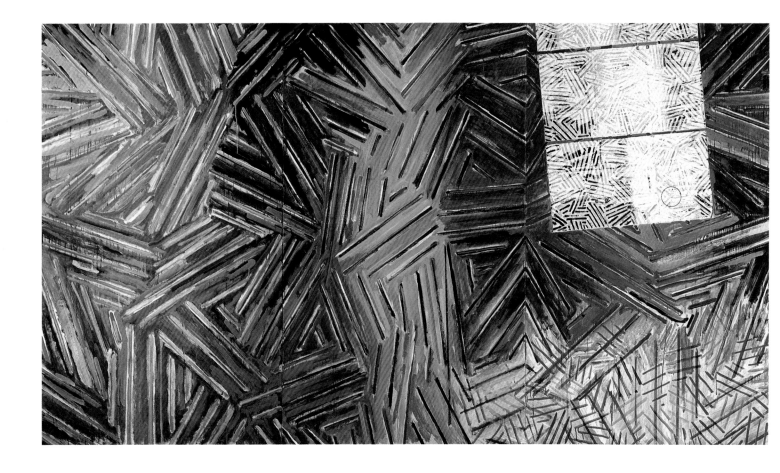

14
Between the Clock and the Bed
1982–83
Encaustic on canvas (three panels)
72 × 126⅛″ (183 × 320 cm)
Virginia Museum of Fine Arts, Richmond
Gift of Sydney and Frances Lewis and The
Sydney and Frances Lewis Foundation

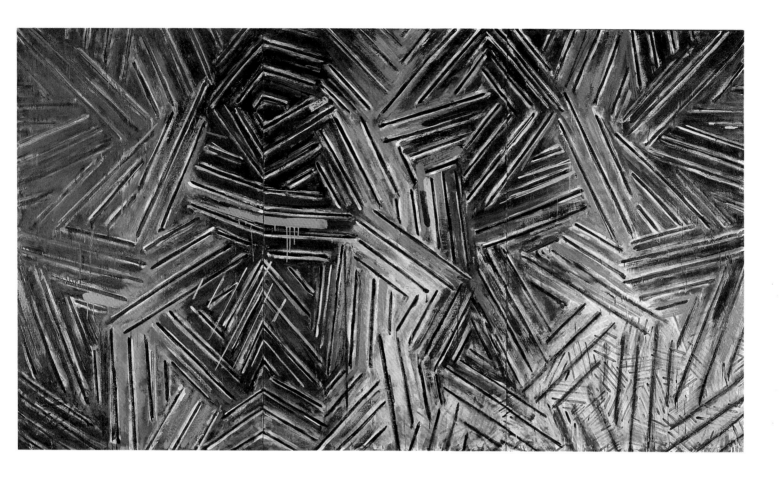

Fig. 20 Edvard Munch, *Between the Clock and the Bed,* 1940–42. Oil on canvas, 59¹⁄₁₆ × 47¼″ (150 × 120 cm). Munch-Museet, Oslo

The title *Between the Clock and the Bed* is the same as that of a painting by Edvard Munch (fig. 20), in which the artist stands uncomfortably between a grandfather clock and a bed with a coverlet decorated in a crosshatch pattern;[106] his studio is in the background. Posed between evocations of time and death (or sex),[107] Munch seems desperate,[108] a fragile individual caught among implacable forces. Johns creates an abstract analogue for the situation that is present in Munch's painting in that the outer sections of the triptych are complementary, whereas the central one, though its pattern crosses into the bordering sections, is unique.[109]

Writing about Johns, Moira Roth emphasizes the degree to which he utilized "emotion-laden material and ran it through a filter of indifference."[110] One might be tempted to suggest a similar strategy in *Between the Clock and the Bed,* for the principal thematic sources appear to be Munch's apprehensive self-portrait and possibly the history of the Christian triptych, which typically is concerned with an aspect of the life and passion of Christ; however, if there is a filter, it is abstraction. Indeed Johns's indifference is possibly overrated, and seen, too often, in absolute or exaggerated terms. His admiration for Leonardo da Vinci's "Deluge" drawings is telling in this regard. He observes that Leonardo depicted "the end of the world, and his hands were not trembling."[111] In his crosshatch compositions, which coincidentally are similar to Leonardo's drawings in their opposing linear forces, Johns maintains his composure even as he considers skulls, corpses, body fragments, and weeping women—the remains of a devastating event. Utilizing the title of the Munch painting, Johns focuses on the human being, who is caught between eternal forces.

Fascinated by the paradoxical idea of suggesting that a work of art may evoke or even possess a sound,[112] Johns started a series of works in the 1960s[113] entitled *Voice* (figs. 21, 22). In these he replicates a Munch-like "scream" for the two-dimensional image. In 1971 Johns created *Voice 2* (fig. 23), about which he said: "After the first *Voice,* I suppose there was something left over, some kind of anxiety, some question about the use of the word in the first painting. Perhaps its smallness in relation to the size of the painting led me to use the word in another way, to make it big, to distort it, bend it about a bit, split it up."[114] In *Voice 2* the linguistic approach is carried a step further; just as the sound of a voice interrupts stillness, the letters of the word mark or intrude on the pictorial surface.

Eleven years later, after several lithographic versions, Johns turned again to the subject in an ink drawing, also called *Voice 2* (pl. 15), which follows closely the composition of the painting. However, the execution in each is altogether unique, demonstrating once more in Johns's oeuvre that things that are linked are nevertheless distinct. He had been utilizing different sorts of translucent supports since 1962,[115] but *Voice 2* could be considered Johns's most extraordinary demonstration of this approach, for the linear complexity and virtuosity of the liquid medium on plastic is astonishing to behold. About the work's discrete parts, Johns wrote:

Shake (shift) parts of some of the letters in VOICE (2). *A not complete unit* or a new unit. The elements in the 3 parts should neither fit nor not fit together. One would like not to be led. Avoid the idea of a puzzle which could be solved. Remove the signs of thought. It is not thought which needs showing.[116]

In *Voice 2* (pl. 15) Johns explores the combination of three separately framed pictures that clearly belong together yet simultaneously assert their uniqueness; indeed the cycle might start at any point.[117] When composed to spell out the title of the work, each section visually leads to the next by repetition of part of the letter at the edges, and there is a link between the far-right and far-left borders. Nevertheless, the overlappings do not precisely coincide, as they do in his earlier painting, *Scent* (pl. 1).

Fig. 21 *Voice,* 1964–67. Oil on canvas with objects, 96 × 69″ (243.8 × 175.3 cm). Private collection

Fig. 22 *Voice,* 1966–67. Lithograph—edition of 30, 48¼ × 31¾″ (122.5 × 80.6 cm). Universal Limited Art Editions, West Islip, New York

15
Voice 2
1982
Ink on plastic (three panels)
35½ × 24″ (90 × 61 cm) (each)
Collection the artist

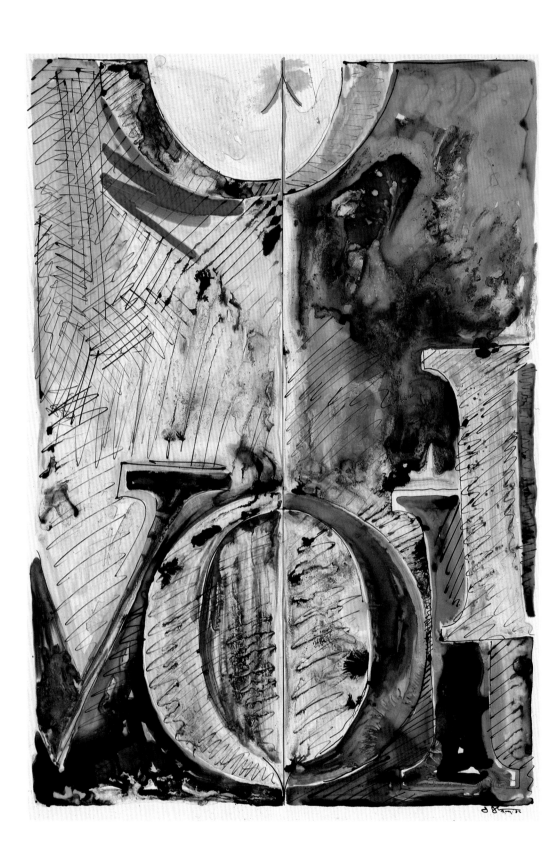

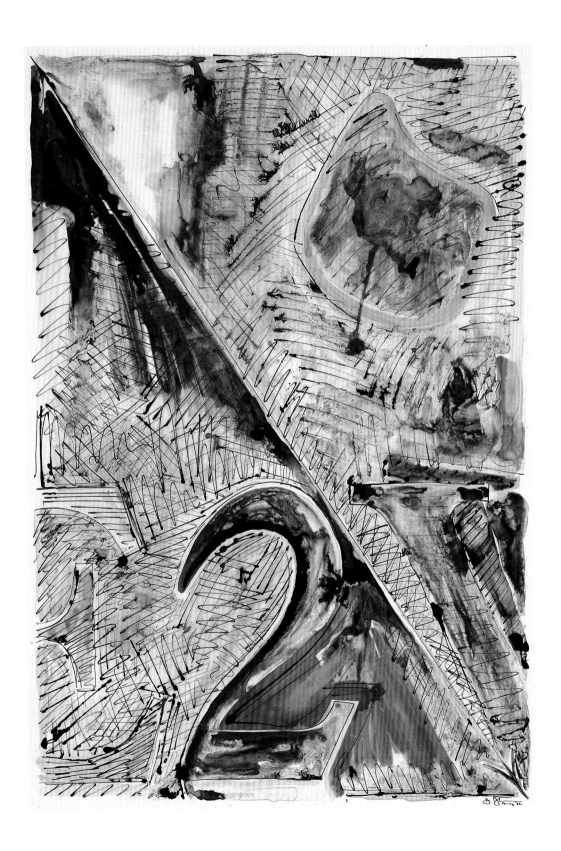

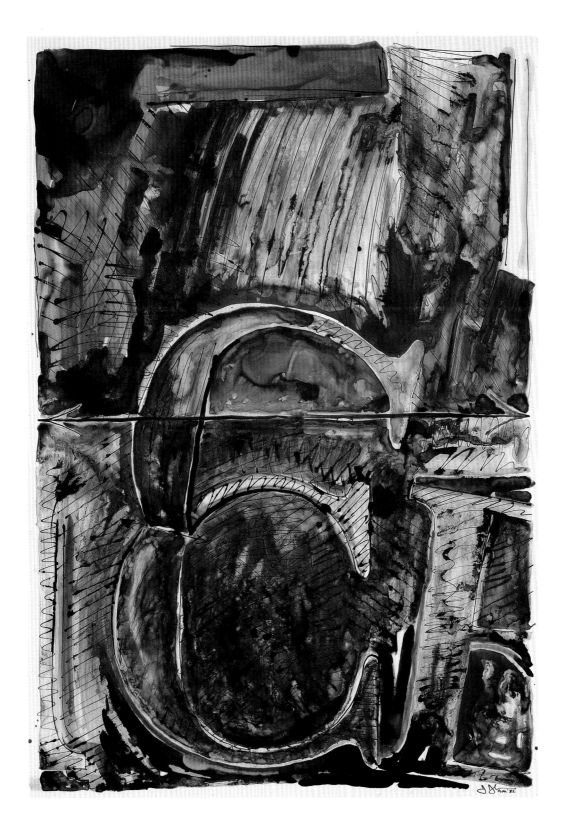

Fig. 23 *Voice 2*, 1971. Oil and collage on canvas (three panels), 72 × 50″ (182.9 × 127 cm) (each). Kunstmuseum Basel

Each section is divided, either vertically, horizontally, or diagonally, echoing the doubling, halving, and shadow effects of the letters. The juxtaposition of loosely geometrical forms above the letters in each panel has an analytical appearance, as if Johns, having created these new language terms, has then formulated their pictorial equivalents. The vaguely recognizable or interpretable sense of the left and center shapes and accompanying ''words'' contrast with the more abstruse *E2* and the idiosyncratic silhouette at the right. This latter form recalls Duchamp's fig leaf and the slice of bread that Johns had used earlier, but is in fact a freehand rendering of the imprint in the painted *Voice 2* (fig. 23) of a part of a chair that sometimes comes with certain ironing machines.[118] A familiar drip falls from the center of the image.[119]

In contrast to the apparent clarity and unitary structure of the numeral *2*, ''VOICE'' is fragmented into new words. But if the parts are put back together and spoken, one realizes that it is the voice itself that accomplishes this; moreover, both the presentation of the word and its utterance are puns on *voici*, the French word for ''here is.'' Hence, Johns's stance is that of the ironic painter-poet, ever questioning the authority, meaning, and structure of language, and the potential of pictorial analogues for such altogether ambiguous notions. At first glance possessing a kind of stability through its stenciled appearance, especially in contrast to the fluid ink medium, the word gradually assumes a bizarre, even self-conscious presence in this highly refined environment.

Dropping the Reserve: Work Since 1982

Dropping the Reserve: Work Since 1982

Fig. 24 *In Memory of My Feelings—Frank O'Hara,* 1961. Oil on canvas with objects, 40 × 60″ (101.6 × 152.4 cm). Stefan T. Edlis Collection

We have already seen the degree to which Johns explores his position as an artist vis-à-vis the painted object. At times he is absent, on other occasions, present, in some manner of speaking. He had certainly gone through these shifts earlier in his career, for example, in the transition from the public subjects including the flags to works such as *In Memory of My Feelings—Frank O'Hara* (fig. 24). Indeed, Johns's art is full of reflections and strategies about how, how not, and whether to be personal and subjective. But in the paintings since 1982, his outlook, especially his concern with death, is increasingly evident on the surface of the canvas, where Johns is less reserved than ever before. "In my early work," Johns said, " I tried to hide my personality, my psychological state, my emotions. This was partly due to my feelings about myself and partly due to my feelings about painting at the time. I sort of stuck to my guns for a while but eventually it seemed like a losing battle. Finally one must simply drop the reserve. I think some of the changes in my work relate to that."[1]

As Johns's art has become more personal, he has devoted yet further attention to renderings of the body. In the crosshatchings he had, with the titles, already evoked the scent, corpse, and sound of a person as well as various parts of a torso. From 1982 the human presence or condition is represented by casts and shadows taken from life, various double images, numerous skulls, and a development of his crosshatch technique by which figurative references are embedded in apparently abstract patterning. In this latest phase of his career Johns fills his paintings with more or less recognizable imagery, but like a dense poem consisting of quickly related yet disparate thoughts, these perplexing and allusive works stimulate the viewer's closest attention to detail.

Johns's reference to "background," discussed earlier, is a useful basis for further distinguishing the work of 1974 to 1982 from that which follows. The dramatic shift that occurred in Johns's art to a great extent concerns the

apparent identity of the picture plane. The crosshatch works were invariably and explicitly painted on a literally evident support (a "ground"), but from 1982 Johns has treated the paintings as a kind of illusionistic ("back") wall. Although this technique had been anticipated in the work of the late 1960s,[2] Johns's renewed interest during the 1980s may in part reflect his overall turn to artistic tradition; the wall is a frequently explored and potentially rich vehicle for artists investigating the degree to which the painting represents an aspect of real space. Also, Johns's increasingly personal subject matter perhaps required him to create settings that approximate an actual space or an experienced environment.

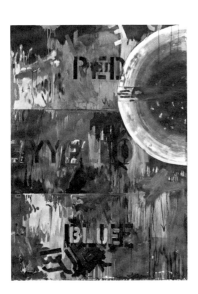

Fig. 25 *Periscope (Hart Crane)*, 1963. Oil on canvas, 67 × 48″ (170.2 × 122 cm). Collection the artist

try to use together
the wall
the layers
the imprint[3]

Johns gives a sense of this problem in *In the Studio*, 1982 (pl. 16), a tour de force painting about modern art and its absorption with a hermetic, self-referential world. There in the studio the range from actual to replicated to depicted entities is explored. Assuming the role of a repoussoir, the stick attached to the edge leads the viewer from natural space toward the surface of the painting. Contrasting and meeting the stick from above is a cast arm; its skin is the most forward-leaning pictorial plane, whereupon a flag-stone pattern is painted.[4] Having been carried visually from real space to the canvas, the viewer finds various pictures, imprints, and specks of paint that establish the flat, modernist plane. Playful contrasts between objects and illusions abound, including a quotation of Georges Braque's trompe l'oeil nail[5] in comparison to an actual hook as well as shadows cast by objects attached to the canvas and painted ones, all typical in jokes about the artist's environ-ment. Yet, paradoxically, these manipulations are not shown on a Cubist-style pictorial plane; as modes by which reality might be grasped, these are appro-priately presented in an anecdotal, though mysteriously lit, lifelike space.

Johns is fascinated by the suggestiveness of segments: "The question of what is a part and what is a whole is a very interesting problem, on the infantile level, yes, on the psychological level, but also in ordinary, objective space."[6] Elsewhere, he writes, "Entities/splitting."[7] Whereas the stick is seemingly whole, the arm is most assuredly not; the composition of it is revealed in the fibrous material seen at the top.[8] The arm "split" from its body may be interpreted as a memento mori, for early in his career Johns wrote of "an object that tells of the loss, destruction, disappearance of objects. Does not speak of itself. Tells of others. Will it include them? Deluge."[9] Such body parts are inescapable phantoms, appearing repeatedly in Johns's art.[10] In works of the early 1960s he depicted upreaching, grasping arms to recall the death of Hart Crane at sea (fig. 25), but the desperation implied in those paint-

16
In the Studio
1982
Encaustic and collage on canvas with
objects
72 × 48″ (183 × 122 cm)
Collection the artist

ings is absent in *In the Studio*. The cast arm,[11] casually attached to the wall,[12] is simply a studio prop, used to suggest memories and emotions.[13] In the guise of a studio necessary, the arm is a model to be copied in two dimensions; hence Johns dutifully depicts it on a sheet of paper but in reversed format. Having been cast from life, the arm has the identity of a "decoy," too.[14] As in his ale cans and other replicated objects, Johns asks the viewer to render a judgment as to the reality of the arm, which, like the stick, casts a shadow.

In the Studio reveals that Johns is not content examining the tenets of modernism but wants to survey the fundamental options before an artist: work as a sculptor directly from the human body, paint from the cast, invent flat, abstract patterns, or face and render the void.[15] It is difficult to ascertain where Johns himself resides in this dilemma, for even his most recent cross-hatch method has simply become one more mode in this troubling work, balancing the representational approach. Indeed, whereas the nonobjective drawing at the top is complete, the lower one is a kind of fragment—like the cast arm—and is apparently melting away. Certainly the crucial event in *In the Studio* is the juxtaposition of the arm and stick, resulting in a comparison between the human emotional sensibility that paints with a free hand and the intellectual approach that defines, measures, and makes use of a straight edge.[16] In this highly hermetic studio environment Johns presents his musings on these possibilities, along with the blank canvas that represents his vehicle and challenge as an artist.[17]

Perilous Night, 1982 (pl. 17), is an altogether moody composition possessing the air of fragmented dreams. Yet notwithstanding its disjunctive character, the painting and its contemporaneous companion work (pl. 18) are neatly organized into diptych compositions. With this arrangement, Johns encourages the viewer to begin making relationships and distinctions.

Compared to the left half of the painting, the right side seems, at least at first, to have the elements of a conventionally represented locale, including a glaring light, shadows, some clarity of focus, trompe l'oeil aspects, and a stepped spatial arrangement to approximate the perceived world. Contradicting this initial impression are the ambiguous, unexplained sections and the conflicting versions of reality, either painted, cast, or found. In diptych compositions Johns sometimes characterizes one side as concerned with a corpse, and in *Perilous Night* there is evidence to consider a related interpretation for the right side. Beside the three arms, graduated in size and thus presumably cast at different phases of life,[18] which may symbolize the Three Ages of Man or even the Trinity, there are painted spots on the limbs. A clue to the source of these discolorations is found in the dark passage in the middle of the right side holding an image of the fallen soldiers from the Resurrection panel of Mathis Grünewald's Isenheim Altarpiece (fig. 26);[19] because arm wounds are a prominent detail of the fallen Christ depicted in the Entombment panel (fig. 27), one could similarly interpret the spots in Johns's painting. The handkerchief in the lower section, quoted from a Picasso etching of a weeping woman (fig. 28), adds to the macabre mood.[20] Thus, in this still-life composition, Johns documents appearances following a death—wounded arms hanging as if hunks of meat and a handkerchief used in mourning. Furthermore, he shows the efforts of artists who dramatize the event. Silkscreened directly onto the canvas is a musical score by John Cage entitled *The Perilous Night;*[21] this suggests both a time of horror and a line from "The Star-Spangled Banner,"[22] itself a reference to Johns's painted flags. Johns attributes the score in his painting to "John C.," perhaps adding a clue in the direction of Christendom. A second artist to have interpreted the drama is a painter of cross-hatch compositions who has rendered the appearance of the three limbs as an abstract tripartite pattern, such as in *In the Studio.*

Fig. 26 Mathis Grünewald, Isenheim Altarpiece, *The Resurrection* (detail), 1513–15. Oil on panel, 105⅞ × 56⁵⁄₁₆" (269 × 143 cm). Musée d'Unterlinden, Colmar

Fig. 27 Mathis Grünewald, Isenheim Altarpiece, *The Entombment* (detail), 1513–15. Oil on panel, 26⅜ × 134½" (269 × 143 cm). Musée d'Unterlinden, Colmar

17
Perilous Night
1982
Encaustic on canvas with objects
67 × 96 × 5″ (170 × 244 × 13 cm)
Collection Robert and Jane Meyerhoff,
Phoenix, Maryland

If the right side of the painting portrays the aftermath, the left renders the dynamic moment, or starting point, that inspired the subsequent appearances and events.[23] There is a sense of something terrible occurring, but in the mysterious Baroque darkness the image is virtually unfathomable. Still the viewer sorely wants to learn the nature of it for this is the only available source for what has resulted on the right half. Apparitions are not unfamiliar in Johns's art, for he had practiced embedding images and newsprint headlines into apparently flat, abstract patterns from the beginning of his career;[24] in perceptual terms, it can be said that he enjoys creating an "unstable . . . visual field."[25] Finally, by comparing the detail from Grünewald, one discovers that on the left Johns has repeated the soldier's sword in an altered position ninety degrees counterclockwise. It is the Resurrection, in all its tumult, that is the source for the subsequent observations on the right half of the painting.

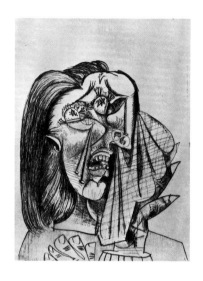

Fig. 28 Pablo Picasso, *Weeping Woman,* 1937. Etching and aquatint, 27½ × 19½" (69.2 × 49.5 cm). Musée Picasso, Paris

With the distinctions between the two halves of *Perilous Night,* Johns explores some of the results of perception when the eye and mind are at work together. The left half exhibits a vision of reality, however dimly and imprecisely seen, wherein a narrative event, in fact legendary, is shown as occurring. On the right Johns depicts with great clarity the subsequent effects, interpretations, and hallucinations that transpire. In his painting the event itself is nearly incomprehensible—a phantasmagoria that is witnessed yet barely grasped. In the aftermath the "vision" is carefully analyzed, but in fragmentary fashion and with clues that themselves could have been invented by the artist. For instance, at the sight of the flashing blade of the sword he might have thought about body fragments.

As a painting about an artist's studio, *Perilous Night* depicts Johns, Grünewald, and Cage organizing a chaotic moment into works of art that have coherence based on the rules of their crafts. The stick, attached along the right edge, is a generalized tool of the artist, who figuratively or literally measures what has transpired on the left, and draws lines to organize, render, and analyze the subject. Following the others, Johns himself attempts, in the words of Hart Crane, "to conjugate infinity's dim margin."[26] He looks through the event to its inherent mystery, creating an endlessly contemplative image. Indeed *Perilous*

18
Perilous Night
1982
Ink on plastic
31⅝ × 40⅞″ (80 × 104 cm)
Collection the artist

Night ought to be considered another of Johns's attempts to distinguish between reality and paradox, whereupon he resigns himself to the permanent state of confusion and doubt these concepts inspire in him.

Since Johns was looking at such highly emotive and personal artists as Munch and Picasso at this time, his appropriation from Grünewald is fascinating to ponder. Possibly it is little more than another "found" image, yet Grünewald's work shares the quality that Johns admires in Leonardo:[27] Grünewald depicts both extraordinary grief and a transcendent moment with a steady, knowing hand. To the extent that Johns's own work is at times threatened by chaos, pessimism, night, and impending death, he marvels at those predecessors who had confronted such themes, even if his own position is less steady, and he requires a flattened version of a maulstick: "I think that one wants from a painting a sense of life. The final suggestion, the final statement, has to be not a deliberate statement but a helpless statement. It has to be what you can't avoid saying."[28]

Fig. 29 Mathis Grünewald, Isenheim Altarpiece, *The Temptation of Saint Anthony* (detail), 1513–15. Oil on panel, 104¹¹/₁₆ × 54¹¹/₁₆" (265 × 139 cm). Musée d'Unterlinden, Colmar

Untitled, 1983 (pl. 19),[29] exhibits the viewpoint of a person sitting in a bathtub. The narrow horizontal off-white strip at the lower right is the top edge of the tub, with the faucets above; a linen basket is to the left, and a rendering of the bathroom door at Johns's Stony Point house serves as the ground for another embedded image. The cast arm reaches toward the tools of the artist—a painted rendering of Johns's lithograph of his well-known sculpture of brushes in a Savarin can[30]—in a gesture that precisely recalls *In the Studio* (pl. 16) and establishes the studio setting. In addition to the illusions and paradoxical contradictions seen earlier, there is a version of Picasso's trompe l'oeil chair caning from *Still Life with Chair Caning,* 1912 (Musée Picasso, Paris), in the form of a hamper. Johns's recent technique is referred to also with a crosshatch drawing in which the marks echo the fingers of the cast arm and brush handles.

The right side of the painting is full of explicit information taken from public contexts. Besides the Savarin logo, Johns introduces behind the cast a Swiss sign warning of avalanches, which adds ominous associations to the arm,[31] and bits of newspaper stories, including a hotel advertisement, "Shoreham: No Place Can Offer More at Any Price," that could apply to Johns's altogether dense painting. The embedded imagery on the left is replete with fantastic possibilities, perhaps so numerous as to cause overstimulation. It is almost a relief to be told finally by the artist[32] that disguised there, upside down, is another detail from the Isenheim Altarpiece, the grotesque demon of the plague from the Temptation of Saint Anthony panel (fig. 29), his body swollen and covered with boils—an exquisite corpse of sorts.

When acknowledging this identification, however, Johns specifically noted "yes, but it's skin."[33] Skin? Once more that word appears in Johns's vocabulary, referring here to a particularly scabious surface. If considered together with the flagstone-cum-wounded appearance of the arm and the skull, the vision of the painting becomes particularly black. Johns depicts a few fragments from a once-whole torso.

19
Untitled
1983
Encaustic and collage on canvas with
objects
48⅛ × 75⅛″ (122 × 191 cm)
Collection Mr. and Mrs. S. I. Newhouse,
Jr., New York

Fig. 30 Marcel Duchamp, *Chocolate Grinder (No. 2)*, 1914. Oil, thread, and pencil on canvas, 25⁹⁄₁₆ × 21¼″ (65 × 54 cm). Philadelphia Museum of Art. The Louise and Walter Arensberg Collection

Further describing this disjointed body is the bathroom fixture. Plumbing makes a wonderfully apt image for the erotic machinery of the human being, and Johns's use of it follows the ambitions of Duchamp in his *Chocolate Grinder* (fig. 30) and window display for André Breton (fig. 31).[34] The sexual references in Johns's work have been masked in a similarly slang fashion elsewhere; recall again *Painting with Two Balls* (fig. 19).[35] Although the faucet in *Untitled* (pl. 19) is ejaculating, it can be construed as a male or female characteristic, as might the skull; but the precedent in *Tantric Detail* (pl. 11) of the juxtaposition of skull and testicles suggests a consistently male identity. With some imagination, this sexual interpretation can be expanded to include the brushes inside the Savarin can, and the allusion of ''chute'' to Duchamp's title for his last work, *Etant Donnés: 1° la chute d'eau, 2° le gaz d'éclairage (Given: 1. the waterfall, 2. the illuminating gas)* (Philadelphia Museum of Art), wherein the waterfall has a sexual connotation.[36] In this melancholy, hallucinatory atmosphere, filled with ghastly implications, the faucet at full throttle offers associations of life and the paintbrushes suggest art's eternal possibilities. This is the soliloquy of someone's waking dream as he lies in his bathtub.

Fig. 31 Marcel Duchamp and André Breton, Window display for André Breton's *Arcane 17,* 1945, Gotham Book Mart, New York. Collection Mme Marcel Duchamp

In *Ventriloquist*, 1983 (pl. 20), Johns uses many of the motifs he had de-
veloped in *Untitled* (pl. 19) and *Racing Thoughts* (fig. 32), both of the
same year and size, but in vertical format.[37] With its diptych composition,
Ventriloquist assumes a resemblance to the untitled Barnett Newman
lithograph of 1961 depicted in the upper right;[38] the double flag (comparing the
forty-eight- and fifty-star versions) and illusionistically painted hinges further
echo that two-part design. In open disposition, the sides form a wall that is, in
effect, plastered with notices. The centered double flag gives the eye a place
to rest and counters the sense of a quickly moving set of images, starting with
the fragmented flag and continuing past the blurred edge of the lithograph.
Along the right border the viewer's attention is brought up short once more by
the painted pink line, reminiscent of the stick in *Perilous Night* (pl. 18) and the
"zip" in the Newman lithograph. The line is used by Johns to "interfere with
the bluntness of the imagery" and to suggest something real, such as a frame
or mirror, that is, some aspect of a place outside the world of the painting.[39]

Johns has identified the large embedded image on the left half of the painting
as a tracing of an illustration by Barry Moser (fig. 33) for a limited edition of
Herman Melville's *Moby-Dick*.[40] Scattered on this side are renderings of
pottery by the early twentieth-century American ceramicist George Ohr,[41]
some of which have the illusion of being barnacles on the body of the enor-
mous mammal. Taken together the imagery on the left speaks of an emphatic
Americanness, yet the characterization is not made assertively, for the flag is
shown in fragmentary form, the pots float as if under water, and that icon of
American literature, Moby Dick, is not clearly discernible at first and is cut off
at the edges.

The left side of *Ventriloquist* establishes a set of given circumstances that are
manipulated in the center and on the right. Johns replicates the structure but
not the color of the original flag. Instead, using opposite or secondary colors,
he turns the pattern underlying the whale into the functional basket weave of
the clothes hamper and exhibits a now upright German vase invested with a
dignified air and a pair of profiles.[42] Indeed, the combination of the running
faucet and cup on one side might be interpreted as a variation of the pairing

Fig. 32 *Racing Thoughts,* 1983. Encaustic
and collage on canvas, 48 × 75⅛"
(122 × 190.8 cm). Whitney Museum of
American Art, New York. Purchase

20
Ventriloquist
1983
Encaustic on canvas
75 × 50″ (190.5 × 127 cm)
The Museum of Fine Arts, Houston.
Purchase: Agnes Cullen Arnold
Endowment Fund

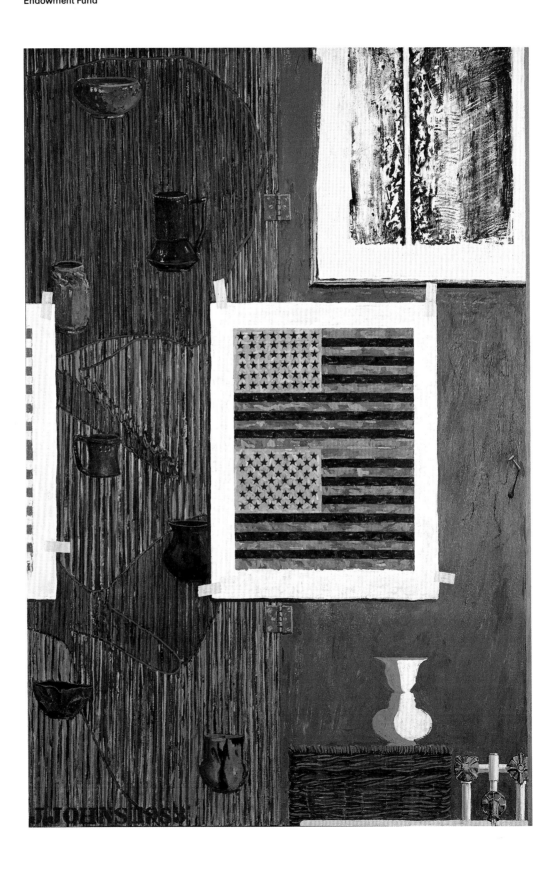

of the sperm whale and pots on the other half of the painting. Furthermore, the pervading spirit of transformation suggests that American mythology and its tradition of transcendentalism, as evoked by Moby Dick, have been made over; filtered through the international practice of abstraction, these become the sources for a work by Barnett Newman. But the lithograph has been reversed, as if to undercut its intended meaning. It may even be that Johns, with his signature on the left, has deliberately played himself off against Newman in this juxtaposition of the two halves of the painting.

The title *Ventriloquist* is an apt characterization for a great deal of the painting. Whether the fictional whale with its mouth open wide is considered a ventriloquist's dummy[43] or Newman's image is understood as the vehicle by which the artist reveals himself and a traditionally American viewpoint, Johns is describing a general phenomenon in which things are not what they appear to be and may have origins elsewhere. We cannot even assume that there are just two players in each of these subtle dramas, although the German vase, with its pair of profiles in silhouette, and the clearly demarcated diptych may imply only two "voices." Just as there is a shadowy third silhouette on the porcelain itself, there may be a third persona, that of the characteristically silent ventriloquist himself "behind" the canvas. This unseen "voice" can be "heard" speculating on the practices of art.

Fig. 33 Barry Moser, *Moby Dick,* from Herman Melville, *Moby-Dick; or, the Whale* (San Francisco, 1979), p. 357. Wood engraving, 10⅜ × 6½" (26.4 × 17.3 cm). © Arion Press

Fig. 34 Man Ray, *Marcel Duchamp as Rrose Sélavy,* c. 1920–21. Gelatin silver print, 8½ × 6¹³/₁₆″ (21.6 × 17.3 cm). Philadelphia Museum of Art. Samuel S. White III and Vera White Collection

Johns made a series of untitled works on paper or plastic (pls. 21–24) that are founded on and start after his untitled painting of 1983 (pl. 19) and lead to *Untitled,* 1984 (pl. 25). The series continues with the works of 1986 (pls. 26–27). The clothes hamper, plumbing fixture, and faucet are consistently present, as is the citation of the Grünewald detail of the demon of the plague (fig. 29), depicted upside down, or upside down and reversed. In most the skull also appears juxtaposed with the faucet, recalling the skull and testicles in *Tantric Detail* (pl. 11). In several the double flag is rendered, but close attention is required, for the artist compares the forty-eight- and fifty-star versions, as he had done in *Ventriloquist* (pl. 20) and earlier.[44] In the course of the works on plastic and paper, Johns uses ink, watercolor, charcoal, chalk, and pencil. Those in ink on plastic have a particularly liquid quality, for pools of color sit or are smeared on the transparent surface. As a group, there is a remarkable range of mood, especially considering that the choice of images is more or less predetermined; the atmosphere or "weather" shifts from dark and turbulent, to cool and gray, to summery and lush.

Having pursued the theme and variation, Johns produced an ebulliently colored painting in 1984 (pl. 25), which exhibits the now familiar diptych format and bathtub viewpoint but has an all-over background that serves as a wall on which images have been attached. The three equally sized and spaced pictures of body parts, previously seen in *Foírades/Fizzles* (pl. 4) and the earlier untitled work of 1972 (fig. 1), form a regular syncopation across the two-part canvas, much as the Newman lithograph, shown in the upper right, is orderly and quickly graspable in composition.[45] Yet, notwithstanding its easily perceived aspects, the body parts and Grünewald details in the painting remain difficult to unravel without clues, and there is a new motif, seen first in the work on plastic of 1983–84 (pl. 24), that has multiple overtones.

Near the place where the skull appeared earlier, Johns has introduced another double, borrowed from the cartoonist W. E. Hill and originally entitled "My Wife and My Mother-in-Law" of 1915. Johns's image has a certain unintended similarity with Man Ray's photograph of Marcel Duchamp as Rrose Sélavy (fig. 34),[46] but rather than possess a secret identity, this double is concerned

21
Untitled
1983
Ink on plastic
24¾ × 36¼″ (63 × 92.1 cm)
The Museum of Modern Art, New York
Gift of The Lauder Foundation

22
Untitled
1983
Ink on plastic
26¼ × 34½″ (66.5 × 87.5 cm)
Collection the artist

23
Untitled
1983
Charcoal and chalk on paper
33⅛ × 45¼″ (84 × 115 cm)
Collection the artist

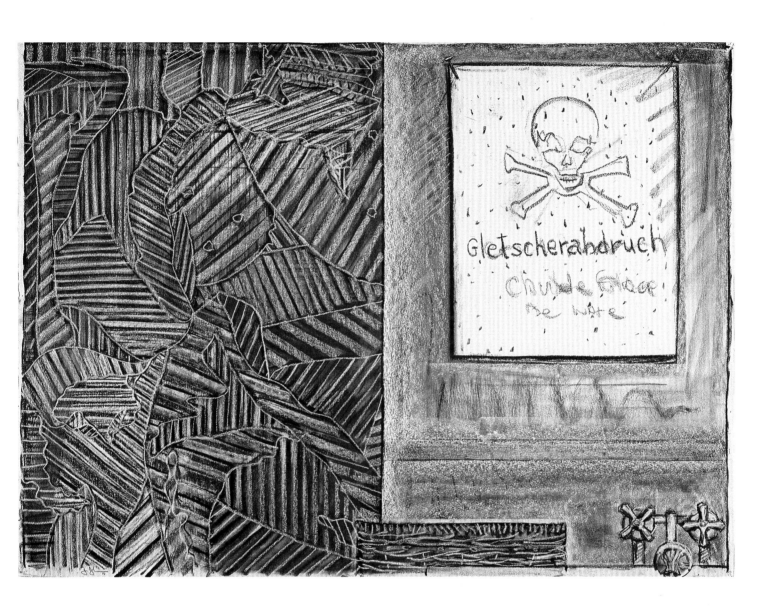

24
Untitled
1983–84
Ink on plastic
26⅛ × 34½″ (66 × 87.5 cm)
Collection the artist

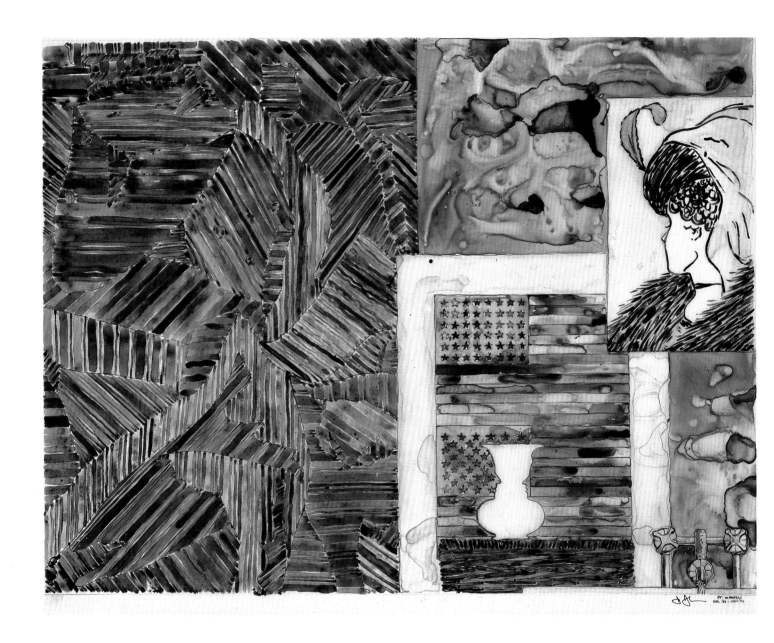

25
Untitled
1984
Encaustic on canvas
50 × 75″ (127 × 190.5 cm)
Collection the artist

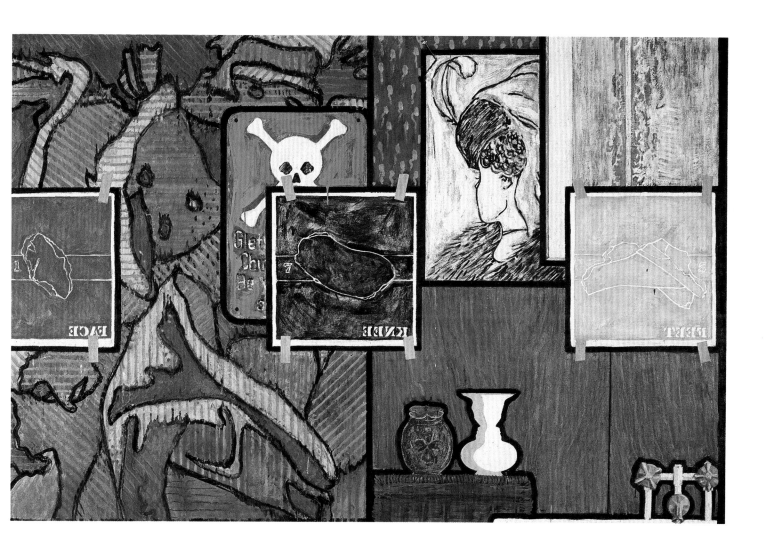

26
Untitled
1984
Pencil and watercolor on paper
25 × 36″ (63.5 × 91 cm)
Collection David Whitney

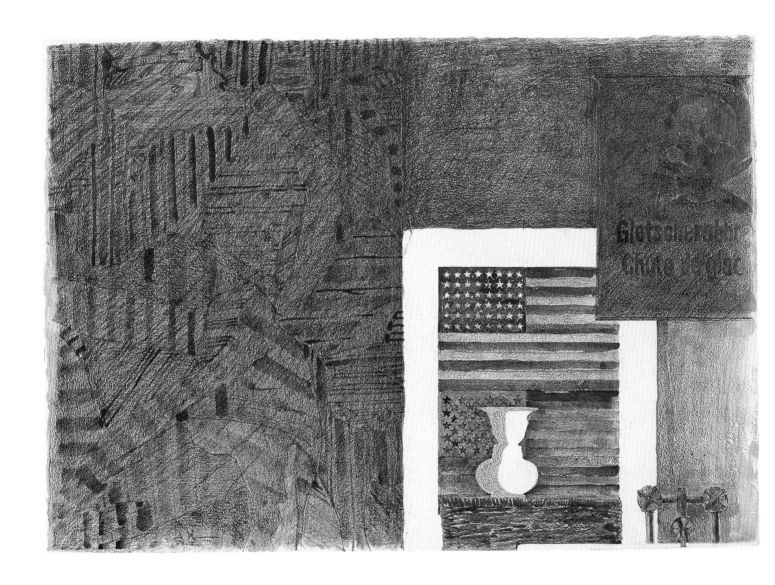

27
Untitled
1986
Watercolor and pencil on paper
24⅝ × 35½″ (62.5 × 90 cm)
Collection the artist

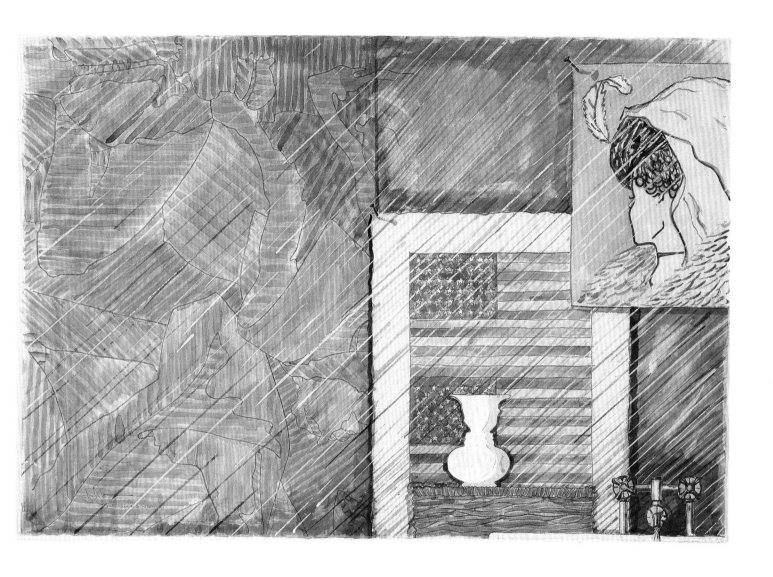

with age. Viewers usually see only one or the other image at first: the fashion-ably coiffed woman, shown in so-called lost profile and from behind, wearing a hat, necklace, and fur, or the mother-in-law, whose eye corresponds to the younger woman's ear, her stupendous nose to the jaw, and mouth to the necklace. In using this comic figure, Johns re-creates a perceptual test, for the speed with which the viewer recognizes either youth or age may be a sign of a personal predilection since neither image is favored. That the mother-in-law figure should replace or be added to the image of the skull in this series is appropriate, for she is clearly a sign of advancing age and mortality. Reinforc-ing the impact of death, the body fragments also are components of a torso or a human presence,[47] whose genitalia have been described earlier.

The lettering given in mirrored fashion, such as the Newman lithograph, calls attention not only to the idea of the double and multiple identity (indeed there is the image, its description, and numerical designation) but suggests ques-tions about space. As in Manet's *Bar at the Folies-Bergère*, 1881–82, or Diego Velázquez's *Las Meninas,* 1656, Johns creates a perplexing field of spatial relationships in which the viewer may have difficulty locating his position. This situation has an effect on the mood of the work, for in the depiction of a wall replete with images, including the mirror reflections from another wall apparently a short distance away, Johns creates an airless environment that induces a mild state of claustrophobia. By excluding a sense of the natural exterior world and any possibility of an exit, Johns describes a predicament similar to that found in Beckett's play *Endgame.* There the walls with pictures are partitions between an inner hell and the one outside; the only sanctuary, however frightening, exists in the middle of the room. Likewise, Johns's world is so hermetic that one starts to hallucinate; for instance, the face of the skull seems to be echoed in the shape to its left, in the pattern on the Ohr pot, and in the design of the plumbing fixture. Hence, the artist stands in the center of the room painting an analogue of the life that he experiences.

Johns made two virtually identical paintings called *Racing Thoughts* immediately before and after *Ventriloquist* (pl. 20). The first version, of 1983 (fig. 32), is composed largely of reds, yellows, and blues, while the second, of 1984 (pl. 28), consists primarily of blacks and grays. His viewpoint is still from a bathtub, with the addition of a pair of corduroy trousers shown hanging nearby.[48] Partly inspired by a scene from television,[49] Johns created a stream of two-dimensional images. He indicated the variety of ways in which these might be related to a wall, including nailed, taped, framed and hung, silhouetted, imagined, and embedded. The background is divided into a diptych consisting of a conventional wall and a pronounced wood-grain door, borrowed from his Stony Point house. The lettering across the top of the right side is cut off and picked up again on the left edge of the same section, and one half of a hinge is shown on the other side. Unifying the diptych panels are the parade of pictures, the repetition of the wood surfaces, and the roughly corresponding division of the sides, with the top left rectangle balancing the one on the lower right.

Racing Thoughts is a compendium of primarily new motifs for Johns; however, all accord with his familiar themes or possess some personal association. Images with an inherent and emphatic abstract structure have always had considerable interest for him, so that when he received a jigsaw puzzle portrait of the face of Leo Castelli, his dealer, as a present from a friend, he used it in several contexts.[50] The reproduction of the Mona Lisa, without her customary landscape background but with her name painted below, has a similar wanted-poster effect[51] and gives Johns the opportunity to refer to two of his favorite artists, Leonardo da Vinci and Marcel Duchamp, the latter through his well-known altered reproduction of Leonardo's painting (fig. 35). Another esteemed colleague is Barnett Newman,[52] once more represented by his 1961 lithograph seen previously in *Ventriloquist*. The pairing of vases again combines one by George Ohr and another, by an anonymous Englishman, produced in Germany in 1977 to celebrate the Silver Jubilee of Queen Elizabeth and incorporating profiles of the queen and Prince Philip on the edges of the two vases .[53] In effect, Johns evokes a domestic museum such

Fig. 35 Marcel Duchamp, *L.H.O.O.Q.,* 1919. Rectified readymade: pencil on a reproduction, 7¾ × 4⅞" (19.7 × 12.4 cm). Private collection

Fig. 36 Edouard Manet, *Portrait of Emil Zola,* 1867–68. Oil on canvas, 57½ × 44⅞" (146 × 114 cm). Musée d'Orsay, Paris

as in the *Portrait of Emil Zola* by Manet (fig. 36); each artist recycles his own images and intermingles works that were influential on him.

Doubleness of identity, appearance, and meaning underlies virtually every object or image in *Racing Thoughts* and makes for a potentially dizzying and delightful range of possibilities. Besides warning of avalanches, the Swiss sign suggests a pun on the word "lecher" perhaps announcing that someone (Leo Castelli?) lusts after Mona Lisa. Given Duchamp's description of the Mona Lisa as "a girl with hot pants,"[54] the faucet might belong to her, but the pervasive lechery allows for male liquids as well; the skull itself can be considered male or female. It has been suggested that Johns had used the skull earlier to refer to the New York collectors Robert and Ethel Scull.[55] Shown with images by famed artists, a photograph of a renowned art dealer, and a silhouette of royalty, the Sculls then join a trinity of art-world personages (artist, dealer, collector). Indeed the old world and new are combined in this genealogy, although Johns's message may be a warning, to "watch out" for the skull/Scull. To the German porcelain with the pair of profiles Johns has added a third one on the body of the vase, as if painted there or as a shadow of himself, and a possible fourth in the 1984 version of *Racing Thoughts* (pl. 28), again as a shadow above and slightly to the left of the vase. (Its prominent nose is directly beneath the Mona Lisa.) Even Newman's abstract "zip," or stripe, usually has larger connotations, as indicated by his works entitled *Onement.* The image embedded into the wood graining is again Grünewald's demon of the plague (fig. 29), upside down; however, the difficulty of visualizing this typifies the character of the double and the ever-present uncertainty in Johns's work.

Racing Thoughts includes both a disguised presence on the left and explicitly or symbolically conveyed body fragments on the right. Moreover, some parts are exposed, others covered; for example, a visage or profile masks a skull. Thus, the painting is a kind of witty, Cubist portrait of a male-female person-age,[56] with the jigsaw puzzle as a model of the fragmentation that is employed.

Racing Thoughts
1984
Oil on canvas
50 × 75" (127 × 190.5 cm)
Collection Robert and Jane Meyerhoff,
Phoenix, Maryland

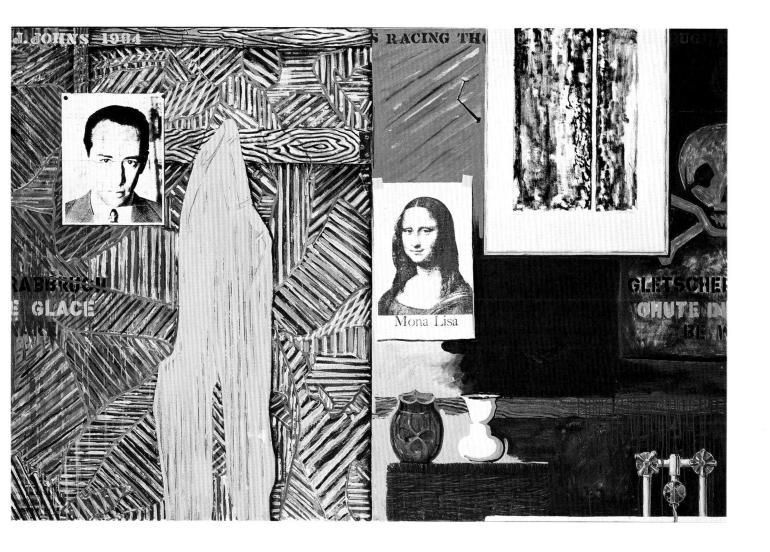

In *Racing Thoughts* Johns also catalogues the types of art one can make. But notwithstanding his admiration for Newman, Johns seems to parody his sublime approach and his "zip" by presenting several meaningless narrow bands in an anecdotal environment and mimicking Newman's compositional structure in the horizontals that divide each half of the painting. In addition to citing a nonobjective work, Johns presents Leonardo's representational one. In this context, the viewer is forced to consider whether the undistinguished photograph of Leo Castelli is as moving and significant as the painting by Leonardo. Next to the Newman is a nail, awaiting the next picture or style.

Johns's depiction of the illusory and multiple aspects of life suggests that interpreting existence is an altogether subjective activity. His world contains easily perceived and recognizable features, less quickly understood aspects, altogether mysterious parts, and abstract structures that are both apparent and implied. Against this range of provisional conditions stands the unequivocal fact announced by the skull and the heading above it.[57] Johns makes that menacing configuration of word and object an absolute standard by which all thinking, artistic or otherwise, is judged and must compete. Framed completely with references that are personal, the painting documents Johns's own fragile assumptions and premises and his effort in "RACING THOUGHT."

Johns had just completed *Summer* in 1985 (pl. 30) when he was asked to
create an illustration for a volume of poetry by Wallace Stevens. In considering
the project, he thought of etching works concerning the seasons but he com-
pleted only one of these (*Summer*). Affected by Stevens's poem "Snow
Man," he started *Winter* (pl. 32) with the idea of using the poet's motif. This
canvas was followed by *Fall* (pl. 31), then *Spring* (pl. 29), all in 1986.[58] In 1987
Johns created a medley of etchings based on the painted "Seasons" but with
different color emphases (pls. 33–36). In contrast to bringing four apparently
unrelated parts into one object, as in his painting of 1972 (fig. 1), Johns, in
each set of "Seasons," created four altogether allied but separate works, in
effect like many suites of his prints[59] or the series of untitled drawings on
paper and plastic that also deal with weather (pls. 21–24, 26–27).

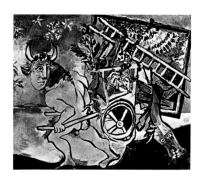

Fig. 37 Pablo Picasso, *Minotaur Moving
His House,* 1936. Oil on canvas, 18⅛ ×
21⅝" (47 × 54.9 cm). ©S.P.A.D.E.M., Paris

While Johns draws on the history of art and poetry, in which series known as
The Seasons and The Ages of Man often intertwine, and landscape variations
and personifications are used to reinforce the themes, the immediate source
for many of the motifs in his "Seasons" is a work by Picasso, *Minotaur Mov-
ing His House,* 1936 (fig. 37).[60] When Johns came upon it in reproduction,[61] he
had himself just established a studio on the island of St. Martin and was
contemplating the possibility of moving to a new location in Manhattan as
well.[62] He therefore decided to employ parts of Picasso's image of transition,
including the wheeled cart on which a ladder and a painting are tied, and
flowery stars, as ongoing accompaniment to the stages of the figure's life.

Linking the four paintings together in the most prominent way is the repetition
of the partial circle with an arm and the large shadow figure, Johns's personi-
fication of an everyman. The appearance of a figure in virtually whole form is a
surprise in his oeuvre, for earlier Johns used only fragments of bodies, names,
photographs of himself, or signs of a past human presence. But here he made
a tracing of his own projected shadow and used it as a template,[63] although
the shadows are always slightly incomplete. The very process by which Johns
imprints himself onto the canvas demonstrates the impossibility of ever being
literally one with or fully rendering himself on the support but shows a method
by which this feat of representation might nevertheless be approached.[64]

29
Spring
1986
Encaustic on canvas
75 × 50″ (190.5 × 127 cm)
Collection Mr. and Mrs. S. I. Newhouse,
Jr., New York

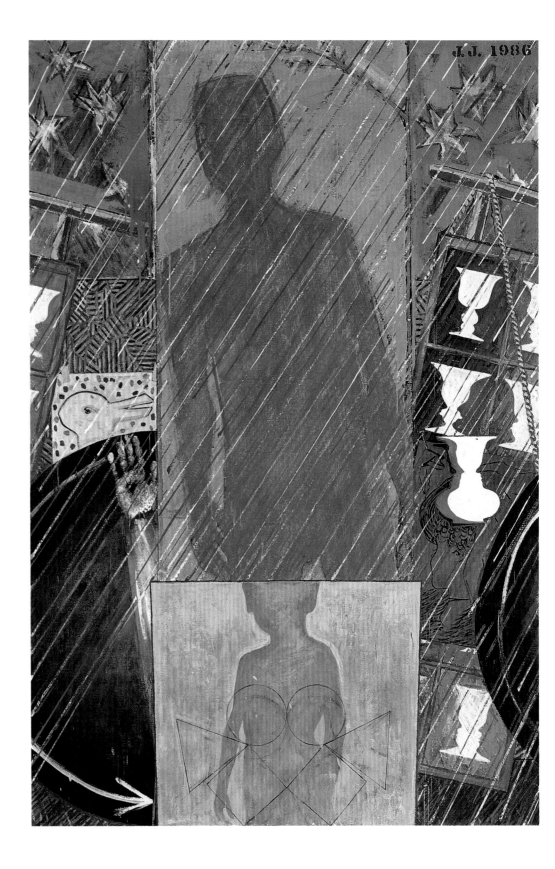

30
Summer
1985
Encaustic on canvas
75 × 50″ (190.5 × 127 cm)
Collection Philip Johnson

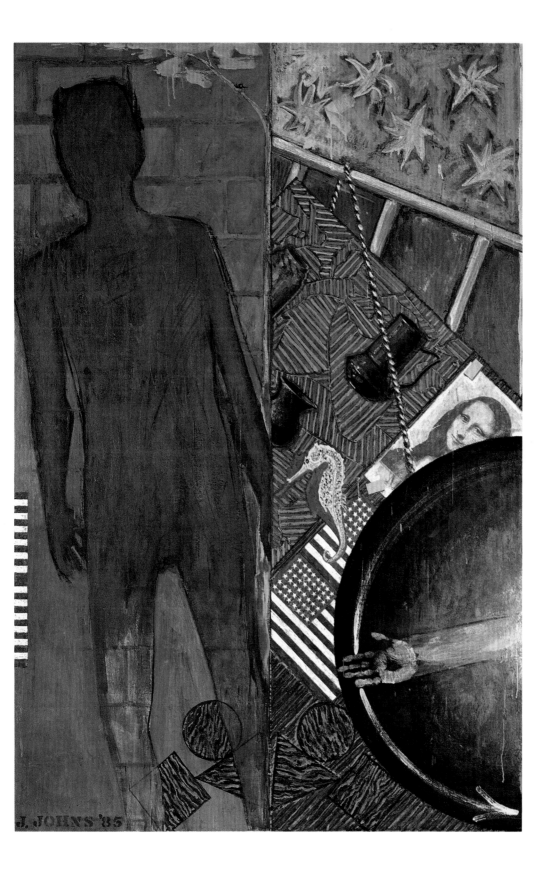

31
Fall
1986
Encaustic on canvas
75 × 50″ (190.5 × 127 cm)
Collection the artist

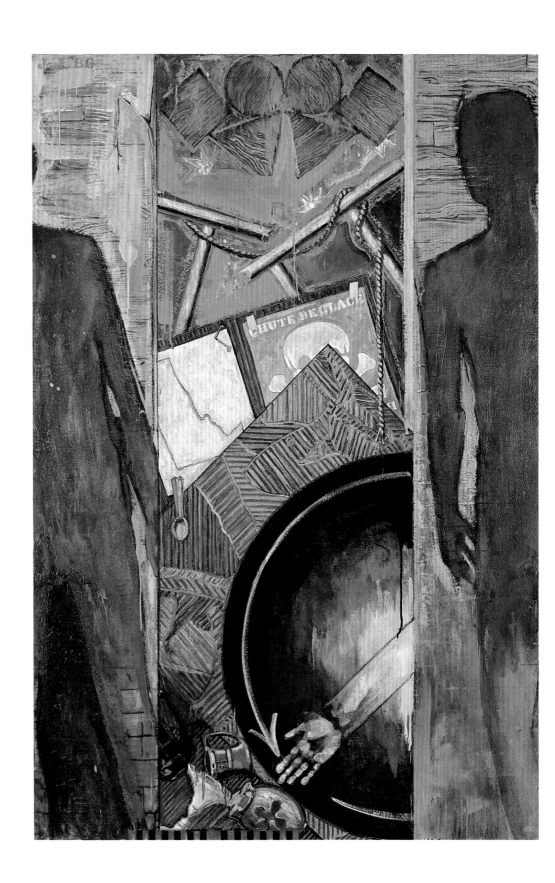

32
Winter
1986
Encaustic on canvas
75 × 50″ (190.5 × 127 cm)
Collection Mr. and Mrs. Asher B.
Edelman and Mildred Ash

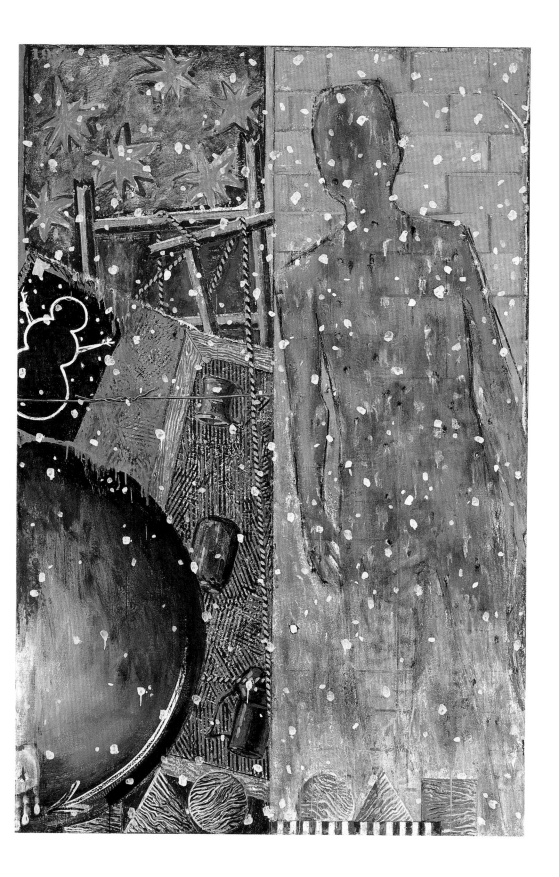

Fig. 38 *Device Circle,* 1959. Encaustic and collage on canvas with objects, 40 × 40" (101.6 × 101.6 cm). Collection Mr. and Mrs. Burton Tremaine, Meriden, Connecticut

Notwithstanding the breakthrough for Johns of dropping his reserve and placing himself within his imagery, there is a lingering reticence in his depicting himself as a shadow—and a semitransparent one at that[65]—and the degree to which such a representation is in fact another decoy. That is, a painted shadow is a mere variation, imitation, or replication of a given individual. Moreover, it is only reported that the shadow was made from Johns's body; while this certainly may be so, no facial features are present to provide conclusive, visual proof. Like a character in a mystery (a Johnsian spy?), a shadow may cause observers to respond uncomfortably or to seek desperately for an identity. The shadow could be viewed as a double, too—a conceit that allows the artist to maintain his privacy and the secrecy of his intentions, even as he depicts a version of himself and his feelings.

While the circular form relates to the cartwheels in Picasso's painting, it has a significant history in Johns's own work. As discussed earlier, he first used an arm painted within a circle in 1963 to refer to the suicidal death of Hart Crane (fig. 25), and a very similar composition with a kind of clock hand is found in *Device Circle* (fig. 38).[66] In "The Seasons" the movement of the arm, as with a compass, seems to establish the curve of the circular contour. The position of the arm is also a record of the current state of the human being and is an omen as well, suggesting the inevitable cycle in which man is subjected to the changing conditions of time. In the twelve-o'clock position, in early childhood, the mechanistic device starts its course, even as the individual is just beginning to learn about life. The arrows indicate the direction that the arm will move in this countdown process.

The rain that characterizes the image of spring is, like all seasonal phenomena and indeed the stages of life, transient. Spring can be considered a metaphor for that period when one sees things for the first time. Therefore Johns represents the child in the middle of the field, as if the domineering "I" in this particular "I-Thou" relationship.[67] At this stage, the child's perception is enormously imaginative and pliant, and the painting is replete with double images. There is the so-called mother-in-law and ceremonial vase seen earlier, several other goblets that show the silhouettes of heads, including the one at

the lower right in the form of an hourglass, the pairs of squares, triangles, and circles, and the double image of a duck-rabbit.[68] Positioning the silhouette of the child beneath that of the adult,[69] enclosed in the columnar form, Johns evinces yet another double, that of a child who has his maturity and a developed point of view within himself, and vice-versa. Notwithstanding the flexibility of the child's mind, Johns depicts this period as a time when things have more than one identity. The child grapples with what to make of this situation.

In *Summer,* the arm is in the nine-o'clock position, or adolescence in terms of the phases of life.[70] The budding branch near the top center of *Spring* is now in full bloom, and the young adult gains male genitalia. Rather than standing at the center of the world as was shown in the naive stage, the figure is juxtaposed so as to participate in a more conventional I-Thou relationship. This is a more straightforward place, and in that spirit Johns even paints a hummingbird and nest that he observed in St. Martin.[71] In this season, with its sharp summer light, the artist depicts himself discovering Leonardo da Vinci, George Ohr, and Americanness, and painting the flags. The doubling and indeed quadrupling of these suggest that the theme remains present at least in perceptual terms; moreover, the embedded image of the demon from Grünewald's altarpiece (fig. 29) reinforces the idea that the complexity of life requires careful discernment. The child's building blocks become more important in *Summer,*[72] as if symbols of the underlying mathematic and scientific premises of nature of which the young adult must become cognizant.

The seahorse is an especially fascinating inclusion in the composition. Goldman writes that it is meant to indicate that the painting was made in Johns's studio in St. Martin,[73] but Rose notes its correspondence to the pregnant horse in the minotaur's cart.[74] Because the seahorse is one of a very few species in which the male can bear offspring, Rose concludes that Johns, who is himself childless but godfather to several children, has included the seahorse as an oblique reference to himself.[75] If indeed male, the seahorse balances the female Mona Lisa, thereby giving the double nature of the human being. Finally, the illusionistic seahorse is a vehicle to depict the most

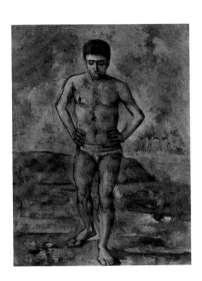

Fig. 39 Paul Cézanne, *The Bather*, c. 1885. Oil on canvas, 50 × 38⅛″ (127 × 96.8 cm). The Museum of Modern Art, New York. Lillie P. Bliss Collection

forward-leaning plane in the picture; in combination with the nail borrowed from Braque, the flat flags, and various other devices, Johns suggests that during the summer of his life, he became familiar with the tenets and practices of modernism.

Fall brings not only bare, drooping branches and a cold light but new knowledge and emotions.[76] While the flags now assume a minor position, the profile of Duchamp takes precedence, and, in fact, it was in the period immediately following the series of flags and targets that Johns discovered the Dada innovator.[77] Accompanying Duchamp's profile in a diptych, Johns includes a portion of the now familiar Swiss avalanche sign. Although unintended,[78] it once more calls to mind the word "chute" in Duchamp's *Etant Donnés: 1° la chute d'eau, 2° le gaz d'éclairage*. More immediately the sign warns that during the fall one must be on guard against what the skull signifies; hence at this time a sense of portentiousness and anxiety starts to fill the world view of the protagonist.

By combining the cool logic of Duchamp and the stark, emotional fear triggered by a skull, Johns signals other related aspects of this season. In *Fall*, order and disorder, and rational process and chance manifestation exist side by side. The pots lie in a jumble at the bottom of the composition, the rope has become tangled and useless in binding the paintings to the broken ladder, and the canvas with the embedded image has been torn apart. Opposed to these signs of chaos is the ascendant position of the building-block forms that even blot out the stars. Johns places the realm of geometry, and by implication, cold, hard inevitable facts of life such as death, itself suggested by the circle, in a dominant role for the individual who has reached maturity. One should see this body of forms as indicative, too, of Johns's increasing admiration of Cézanne,[79] whose emphasis on geometrical shapes is proverbial but who was also much drawn to the melancholic subject of skulls. Indeed, the very pose of the shadow figure is similar to Cézanne's *Bather* (fig. 39), a work Johns reveres along with his *Young Man with a Skull* (fig. 18).[80] Thus, in the mature phase of his life, Johns looks to the twin pillars of Duchamp and Cézanne for inspiration.[81]

Fall may be understood as a time of transition, when both the harvest of summer and the oncoming deprivations of winter intersect; thus Johns combines the slanting pose of *Summer* on the left, departing the scene, and the emerging personification of winter, entering at the right. In effect, Johns's surrogate shadow is halved and the two opposing selves vie for control. Indicative of the familiar theme of divided states of being, the partial figures signify the split between the realms of thought and feeling that are suggested above.[82] In this phase it seems that the "I" not only looks at the world but at itself, in the mirror as it were, with a resulting diminishment, or "fall," of the self-confidence seen in *Summer*.[83]

Johns's characteristically gray tonality overlaid with flakes of snow sets the mood for old age in *Winter*.[84] Recalling the cast arms in the paintings of 1982–84, the arm now dangles, the weight of gravity its dominant influence; if needed, an arrow moving clockwise reinforces the positioning of the limb. While near the end, Johns allows for an afterlife that will be documented on the unused portion of the clockface. A wintry starry sky has replaced the geometrical forms, now returned to the lower edge of the canvas, where they have somewhat lost their importance and coherence. Similarly, the Ohr pots are shown upside down and falling, and the crisscrossed knot of the rope is ineffectual.[85] A sense of inevitability is pervasive, but notwithstanding its reference to Stevens's poem, the snowman is a reminder of the simplicity of childhood and of the joyous, attractive aspects of winter. One might even say that the arms of the silhouette possess the vitality that is lacking in the limb on the clock, except that the pose equally recalls Hart Crane's suicidal leap and a crucifixion as well.

The shift of the figure to the right side of the composition can be understood as part of a clear and predetermined progression in the series of canvases. After being presented in the center of the universe in two parts, with its future predicted in the shadow above, the figure takes its full form on the left of *Summer*. In *Fall,* it is shown halved again, before the final move to the right side of the "world." In this scheme, while each phase of development contains some aspect of another within it, there are meaningful pairings between

33
Spring
1987
Eight-color intaglio, edition of 73
26 × 19″ (66 × 48 cm) (sheet)
Collection Leonard I. and Jane Korman,
Fort Washington, Pennsylvania

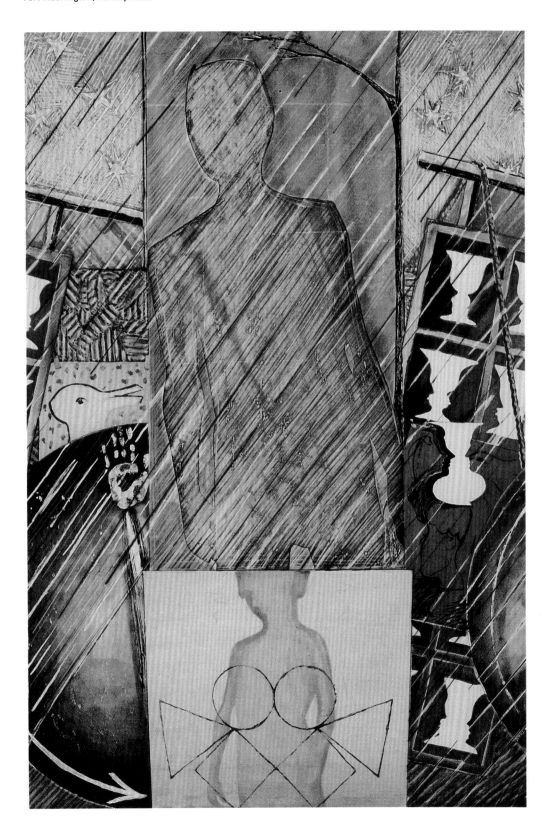

34
Summer
1987
Eight-color intaglio, edition of 73
26 × 19″ (66 × 48 cm) (sheet)
Collection Leonard I. and Jane Korman,
Fort Washington, Pennsylvania

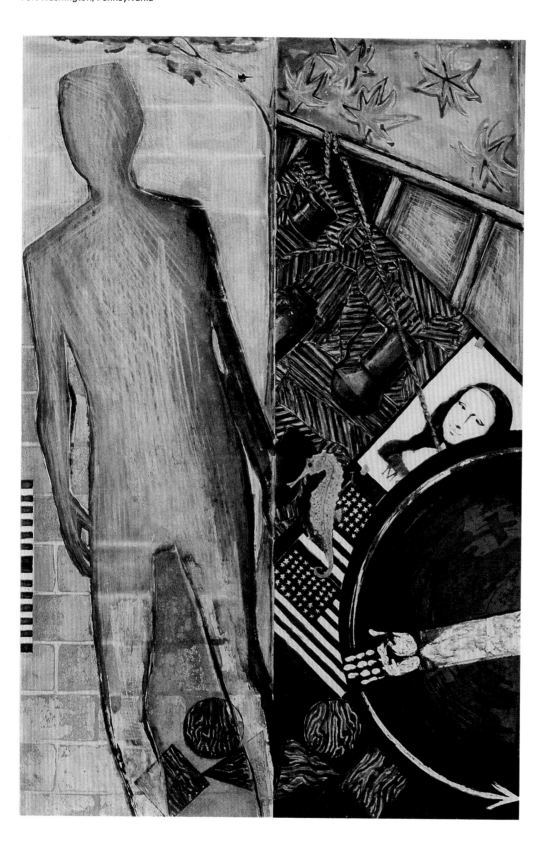

35
Fall
1987
Eight-color intaglio, edition of 73
26 × 19″ (66 × 48 cm) (sheet)
Collection Leonard I. and Jane Korman,
Fort Washington, Pennsylvania

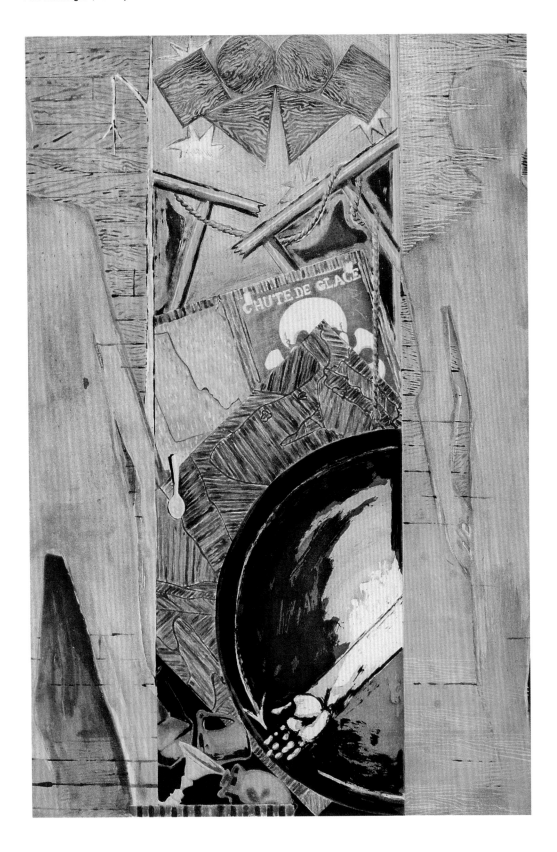

36
Winter
1987
Eight-color intaglio, edition of 73
26 × 19″ (66 × 48 cm) (sheet)
Collection Leonard I. and Jane Korman,
Fort Washington, Pennsylvania

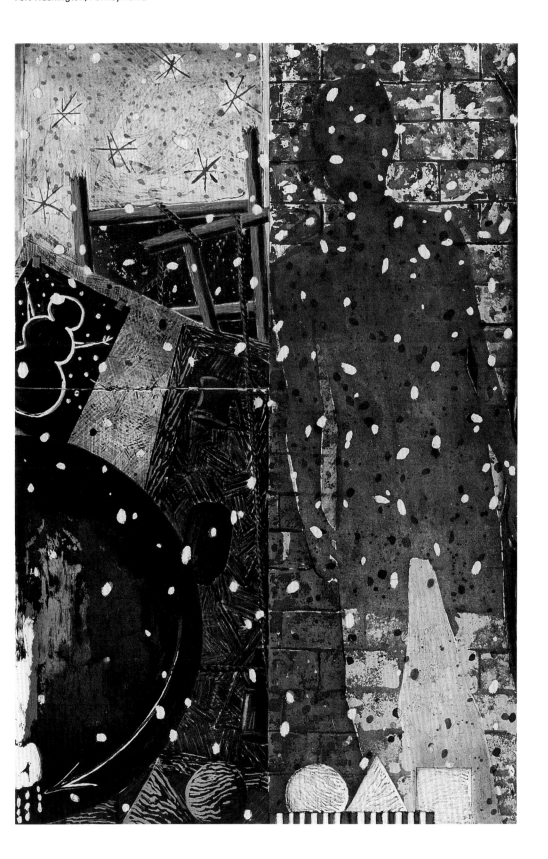

the depictions. As transitional periods, *Spring* and *Fall* each reveal the figure in segments, whereas *Summer* and *Winter* are more emphatically stated with a single shadow; *Spring* and *Winter,* at the beginning and end of the cycle, are similarly characterized by precipitation (the Deluge?). As in most renderings of The Seasons, the events are unified by their existing under the influence of a celestial aegis.

Although the position of the shadow figure changes in each period, it is never particularly active. Rather, recalling the self-portrait by Munch (fig. 20), the personage is more a victim of or witness to his own transitions than a perpetrator. In contrast to some depictions of The Seasons or The Ages of Man in which the individual might struggle with the prevailing conditions, Johns's everyman seems unable to strive beyond the preordained situation. Johns's often-described indifference may conceal, then, a degree of suffering, for the aspects of human development are a "given" set of circumstances that the individual endures; indeed nature too, which is as rare in Johns's art as a full figure, simply undergoes changes.

By turning to a depiction of The Seasons[86] and assuming an allegorical approach, Johns affirms his belief that historic art is a critique of contemporary art[87] and suggests in effect that the latter may have failed to confront some of the most fundamental subject matter of life. In essaying this theme Johns is even compelled to modify his earlier practice and to depict a full figure. But his "Seasons" are a notable new step in the tradition, for Johns adds psycho-perceptual states of development and vivid iconographic elements.

Johns's attention to earlier art subsumes a thorough absorption with Cubism, too, and in that spirit his work is visually demanding and uningratiating.[88] He had already used impersonal found materials, especially newsprint and advertising labels, recycled motifs, and multiplied identification and meaning for certain forms, as did the Cubists. But in "The Seasons," he reaches a new level of Cubist-style hermeticism, forcing the viewer to look closely and to recall what was just seen. While combining interior and exterior views on the

same plane, as in a number of Cubist canvases, Johns rarely invites thoughts of nature in its resplendence. Rather, all is strictly contained by the picture plane, and the viewer is persuaded to dwell in a welter of self-reflective manipulations.

If, as Rose suggests, Johns's search for "wholeness . . . in a fragmented, discontinuous world" has brought him to this point in his life,[89] his exploration is hardly over. His surrogate shadow remains characteristically masked and gray, its portrayal evocative of still-unrevealed feelings. What is clear is that Johns has entered a new phase of his career, and, in a fashion that recalls earlier masters at similar points in their lives, he has chosen to make encompassing statements that reflect the history of art and the character of the human condition.

Notes

Introduction: "The Condition of a Presence"

1. In Vivien Raynor, "Jasper Johns," *Artnews*, vol. 72, no. 3 (March 1973), p. 21.

2. Quoted in Michael Crichton, *Jasper Johns* (New York, 1977), p. 20.

3. Cited in David Shapiro, *Jasper Johns Drawings 1954–1984* (New York, 1984), p. 31.

4. See David Sylvester, "Interview," in Arts Council of Great Britain, London, *Jasper Johns Drawings* (Museum of Modern Art, Oxford, September 17–October 13, 1974), pp. 13–14.

5. Jasper Johns, "Sketchbook Notes," in Richard Francis, *Jasper Johns* (New York, 1984), p. 110.

6. Johns uses this word in his "Sketchbook Notes" (Ibid.).

7. Quoted in Leo Steinberg, *Other Criteria* (New York, 1972), p. 31.

8. Jasper Johns, "Sketchbook Notes," *Art and Literature*, vol. 4 (Spring 1965), p. 192.

Crosshatch Paintings, 1974–82

1. See Pierre Cabanne, *Dialogues with Marcel Duchamp*, trans. Ron Padgett (New York, 1971), p. 43.

2. Barbara Rose, "Jasper Johns: Pictures and Concepts," *Arts Magazine*, vol. 52, no. 3 (November 1977), p. 149.

3. Charles Harrison and Fred Orton, "Jasper Johns: Meaning What You See" *Art History*, vol. 7, no. 1 (March 1984), p. 88.

4. In Crichton, *Johns*, p. 59.

5. See Richard Field, Center for the Arts, Wesleyan University, Middletown, Conn., *Jasper Johns: Prints 1970–1977* (March 27–April 25, 1978), p. 61; Roberta Bernstein, *Jasper Johns' Paintings and Sculptures 1954–1974: The Changing Focus of the Eye* (Ann Arbor, 1985), pp. 70–74; and Shapiro, *Johns*, pp. 17–18.

6. There is also a likeness to Picasso's *Woman of Algiers*, 1955; see Bernstein, *Johns*, pp. 136, 237, n. 26.

7. Also consider Feinstein's interpretation of the hatches as erotic (Roni Feinstein, "Jasper Johns' *Untitled* [1972] and Marcel Duchamp's *Bride*," *Arts Magazine*, vol. 57, no. 1 [September 1982], pp. 90–91) and Sundell's explanation of the hatches as marks on architectural drawings to fill space (Nina Sundell, *The Robert and Jane Meyerhoff Collection 1958–1979* [Phoenix, Md., 1980], p. 31).

8. Rose, "Pictures and Concepts," p. 149; see also Suzi Gablik, "Jasper Johns's Pictures of the World," *Art in America*, vol. 66, no. 1 (January–February 1978), pp. 64–65.

9. From the beginning of his career, Johns has enjoyed looking at the appearance of the world and discovering its complexities: "At every point in nature, there is something to see. My work contains similar possibilities for the changing focus of the eye" (The Museum of Modern Art, New York, *Sixteen Americans*, ed. Dorothy Miller [December 16, 1959–February 14, 1960], p. 22). Elsewhere, he compares his processes to the effects of city planning (Johns, "Sketchbook Notes," *Art and Literature*, p. 185).

10. Rose, "Pictures and Concepts," p. 149.

11. Johns, "Sketchbook Notes," in Francis, *Johns*, p. 110.

12. About the car, Johns said that the pattern can have a thoughtful appearance as in a Matisse painting or look unsophisticated, such as in street art, but that he, in fact, sought neither appearance (see Roberta Bernstein, "Johns and Beckett: Foirades/Fizzles," *The Print Collector's Newsletter*, vol. 7, no. 5 [November–December 1976], p. 143). Johns also recalled a photograph of a tree painted with a hatching pattern (Crichton, *Johns*, p. 61), and much earlier in his career he himself covered a book with paint and newspaper fragments with medium (Crichton, *Johns*, pl. 17).

13. Johns, "Sketchbook Notes," *Art and Literature*, p. 192.

14. The artist discussed this in an interview with the author in August 1987 (hereafter referred to as Interview, August 1987; other interviews will be similarly noted).

15. Crichton reports that Johns happened to see a pattern of flagstones painted on a wall in Harlem, which was the source of his usage (*Johns*, pp. 54–55).

16. Johns explains that the number on each slat refers to the order in which it was laid down (Interview, August 1987).

17. Shiff wants to stress that unlike the relationships between the first two panels (both in oil), and the third and fourth (in encaustic), there is no "transgression" between the second and third. (Richard Shiff, "Anamorphosis: Jasper Johns," in The Grunewald Center for the Graphic Arts, Wight Art Gallery, University of California, Los Angeles, *Foirades/Fizzles: Echo and Allusion in the Art of Jasper Johns* [September 20–November 15, 1987], p. 154.) However, the meeting of the red and black forms in the lower center certainly indicates a kind of acknowledgment or rapprochement. Within this collection of essays are a number of observations that are quite similar to those discussed here, a coincidence noted just as this book was in editorial stage.

18. Johns reported that the flagstones in the left section were made by cutting shapes from silk, covering these with paint, and pressing them onto the canvas; in the right section, flagstones were applied with encaustic and brushes (Interview, August 1987).

19. In Peter Fuller, "Jasper Johns Interviewed: [Part] I," *Art Monthly*, no. 18 (July–August 1978), p. 12.

20. Johns made use of stretchers in *Canvas*, 1956 (Crichton, *Johns*, p. 21), *Fool's House*, 1962 (pl. 98), *According to What*, 1964 (pl. 115), and *Hinged Canvas*, 1971 (Field, *Johns*, no. 139).

21. Francis describes Johns "covering himself with oil and pressing against a sheet of drafting paper, which was then dusted and rubbed slightly with powdered graphite" (*Johns*, p. 54).

22. Crichton, *Johns*, pl. 112. See also *According to What*, for a stretcher seen behind a painting, and *Untitled*, 1954 (Crichton, *Johns*, p. 27), in which the human behind is shown in relation to the abstract pattern. In this regard, one recalls the poem "Joe's Jacket" by Johns's friend Frank O'Hara, which begins: "Entraining to Southampton in the parlor car with Jap [Johns] and Vincent, I see life as a penetrable landscape lit from above" (*The Collected Poems of Frank O'Hara*, ed. Donald Allen [New York, 1971], p. 329).

23. See Harrison and Orton, "Johns," pp. 97–98.

24. See Shapiro, *Johns*, pl. 127.

25. In this regard, Johns said about *Watchman*: "Watch the imitation of the shape of the body" (Johns, "Sketchbook Notes," *Art and Literature*, p. 185).

26. Ibid.

27. The idea that the crosshatchings might on occasion allude to or be a metaphor for skin was recently reinforced in conversations between the artist and Jill Johnston; see Johnston, "Tracking the Shadow," *Art in America*, vol. 75, no. 10 (October 1987), p. 132.

28. See *Handprint*, 1964 (Crichton, *Johns*, p. 13), *Untitled*, c. 1954 (Crichton, *Johns*, p. 27), *Target with Plaster Casts*, 1955 (fig. 2), *The Critic Sees*, 1961 (Crichton, *Johns*, pl. 90), *Periscope (Hart Crane)*, 1963 (fig. 25), *Subway*, 1965 (Crichton, *Johns*, pl. 113), *Passage II*, 1966 (pl. 124).

29. The example of Magritte in *Discovery*, 1927 (Suzi Gablik, *Magritte* [Greenwich, Conn., 1970], pl. 52) may be applied here to support the comparison of a painted figure.

30. Crichton, *Johns*, pl. 152.

31. Interview, August 1987. Johns further described the work: "One can say that the physique of the painting embodies the thought, allowing the mind to perceive both at once; or the two can be split, allowing one to sense them at different times" (Christian Geelhaar, *Jasper Johns: Working Proofs* [Basel, 1980], p. 47).

32. Thomas B. Hess, "On the Scent of Jasper Johns," *New York Magazine*, vol. 9, no. 6 (February 9, 1976), p. 67.

33. David Bourdon, "Jasper Johns: 'I Never Sensed Myself as Being Static,'" *Village Voice*, October 31, 1977, p. 75.

34. For additional comparisons to Pollock, see David Sweet, "Johns's Expressionism," *Artscribe*, no. 12 (June 1978), pp. 42–45.

35. Shapiro, *Johns*, p. 19.

36. A second, larger version, *Corpse and Mirror II*, was painted in 1974–75 (Crichton, *Johns*, pl. 163).

37. He had also painted three versions of numerals in 1958–59 (Crichton, *Johns*, pls. 24–26), and *False Start* and *Jubilee*, in 1959 (pls. 51–52).

38. Johns, "Sketchbook Notes," in Francis, *Johns*, p. 109.

39. Quoted in John Cage, "Jasper Johns: Stories and Ideas," in The Jewish Museum, New York, *Jasper Johns* (February 16–April 12, 1964), pp. 23–24.

40. Johns's well-established interest in Magritte encourages comparison with the Belgian's double images, for example *Pink Bells, Tattered Skies*, 1929–30, and *The End of Contemplation*, 1927 (David Sylvester, *Magritte* [New York, 1969], repros. pp. 38–39).

41. Jasper Johns, "Sketchbook Notes," *0 to 9*, no. 6 (July 1969), p. 2.

42. See also Hess, "On the Scent of Jasper Johns," p. 66.

43. Johns explains that he variously uses tracings, projections, or a mirror itself to produce such images (Interview, June 1987).

44. Earlier in his career, Johns said that "generally, whatever printing shows has no significance to me" (Walter Hopps, "An Interview with Jasper Johns," *Artforum*, vol. 3, no. 6 [March 1965], p. 32).

45. Johns, "Sketchbook Notes," *Art and Literature*, p. 185.

46. See Field, *Johns*, p. 50.

47. Johns's often-discussed urge toward negation is analyzed by Barbara Rose in "Decoys and Doubles: Jasper Johns and the Modernist Mind," *Arts Magazine*, vol. 50, no. 9 (May 1976), p. 69.

48. Crichton, *Johns,* p. 27; see also *No, 1961* (pl. 80).

49. David Sylvester, "Interview," *Jasper Johns Drawings,* p. 10.

50. For a discussion of this use of the *X,* see Jeff Perrone, "Jasper Johns's New Paintings," *Artforum,* vol. 14, no. 8 (April 1976), p. 50; and Field, *Johns,* p. 50.

51. For example, Cuno has pointed to Magritte's painting *The Use of Words I,* 1928–29, in which *miroir* and *corps de femme* are juxtaposed (James Cuno, "Jasper Johns," *Print Quarterly,* vol. 4, no. 1 [March 1987], p. 85).

52. Later, in 1974–75, Johns painted a single panel entitled *Corpse* (Crichton, *Johns,* pl. 164).

53. One might also compare Hart Crane's metaphor of the mirror in "Legend," *The Poems of Hart Crane,* ed. Marc Simon (New York, 1986), p. 3.

54. Johns says that no system of mark making is present in this work (Interview, August 1987).

55. Rosalind Krauss, "Jasper Johns: The Functions of Irony," *October,* vol. 2 (Summer 1976), pp. 96–97. For his part, Johns says Krauss is "reading in" this resemblance (Interview, August 1987).

56. Quoted in Cage, "Stories," p. 24.

57. Interview, August 1987. Harrison and Orton relate the iron to "an iron coffin" from Hart Crane's "Passage" as a kind of "memento mori device" (Johns, p. 90). But this interpretation does not seem appropriate here. Man Ray's sculpture of an iron, *Gift,* 1921 (Museum of Contemporary Art, Chicago, *In the Mind's Eye: Dada and Surrealism* [December 1, 1984–January 27, 1985], repro. p. 175), could be recalled, as well as Picasso's *Woman in an Armchair,* 1913 (The Museum of Modern Art, New York, *Pablo Picasso: A Retrospective* [May 22–September 16, 1980], repro. p. 173). Picasso's *Woman Ironing* has been compared by Cuno ("Voices and Mirrors/Echoes and Illusions," in Wight Art Gallery, *Foirades/Fizzles,* p. 206). Johns's "i-rony" is also discussed by Joseph Masheck in "Jasper Johns Returns," *Art in America,* vol. 64, no. 2 (March–April 1976), p. 67.

58. For example, *Device Circle,* 1959 (fig. 38). Johns often uses the circular imprint from a can of paint, probably because it is not his but is "taken"; see statement in Crichton, *Johns,* p. 55. In Hart Crane's "Cape Hatteras," a poem well known to Johns, the circle is infinite as well as being the opening of a periscope or an eye; through this opening, the viewer can focus on a section of something vast. In the process, space is "splintered" (*The*

Poems of Hart Crane, pp. 77–78, lines 33–34; p. 79, line 78, 97; p. 80, line 100; p. 80, line 120).

59. Judith Goldman, *Jasper Johns: 17 Monotypes* (West Islip, 1982), p. 84. In her essay Goldman also points to a work of the same title by Munch. Johns described seeing an etching of Picasso's *Weeping Woman* in Aldo Crommelynck's Paris atelier in 1975; he added that the title was a way to give the work a particular slant (Interview, August 1987). He derives this approach from Duchamp, who described the title of *Nude Descending a Staircase* (Philadelphia Museum of Art, The Louise and Walter Arensberg Collection) as being an extra color (Interview, November 1987).

60. Interview, August 1987. Johns had collaborated with a writer just once before in his career on the lithograph *Skin with O'Hara Poem,* 1963–65 (Crichton, *Johns,* pl. 110).

61. Geelhaar, *Johns,* p. 35.

62. For a complete discussion, see Richard Field, "The Making of *Foirades/Fizzles,*" in Wight Art Gallery, *Foirades/Fizzles,* pp. 99–126.

63. See Bernstein, "Johns and Beckett: Foirades/Fizzles," pp. 141–45; and Whitney Museum of American Art, New York, *Foirades/Fizzles* (October 11–November 20, 1977).

64. Another related example of this is *Wall Piece,* 1968 (Crichton, *Johns,* pl. 136).

65. Interview, August 1987.

66. Ibid.

67. Interview, December 1987. Recall *The Barber's Tree* (Crichton, *Johns,* pl. 166).

68. The Museum of Modern Art, *Sixteen Americans,* p. 22.

69. See Judith Goldman, in Thomas Segal Gallery, Boston, *Jasper Johns Prints 1977–1981* (October 24–December 2, 1981) p. 12.

70. Johns describes later works entitled *Usuyuki* as possessing colorations that correspond loosely to costumes and other characteristics of the kabuki (Interview, August 1987).

71. John Cage, *Silence* (Middletown, Conn., 1961) p. 130.

72. Johns says the shape, which is also seen in *No,* 1961 (Crichton, *Johns,* pl. 80), and elsewhere, is based on a chair that is joined to an old-style ironing table (Interview, September 1987). Mark Lancaster recalls that the shape reminded Johns of Duchamp's *Female Fig Leaf,* 1951 (Collection Mme Marcel

Duchamp), and that the imprint in the extreme upper right was made with the base of a turpentine can (Mark Lancaster to the author, November 1987).

73. Crane, "Cape Hatteras," *Poems,* pp. 77–84.

74. Ibid., p. 77, line 33; p. 80, line 120.

75. Cited in Joseph E. Young, "Jasper Johns: An Appraisal," *Art International,* vol. 13, no. 7 (September 1969), p. 51.

76. The hand print and crosshatch are also joined in *Untitled,* 1977 (Shapiro, *Johns,* pl. 127).

77. Johns notes that Céline was the only writer he could concentrate on at this time. Of particular fascination to him was the hallucinatory quality of the writing, as well as Céline's capacity to combine "wholehearted, grandiose, private, and funny" characteristics (Interview, August 1987).

78. For altogether murky reasons, Perrone interprets *Céline* as having to do with the male castration complex (Jeff Perrone, "The Purloined Image," *Arts Magazine,* vol. 53, no. 8 [April 1979], pp. 137–39).

79. Louis-Ferdinand Céline, *Journey to the End of the Night,* trans. Ralph Mannheim (New York, 1983), p. 8.

80. In connection with the cicada, Donald Kuspit writes of the locust as "a death's head, emblematic of the holocaust," in "Personal Signs: Jasper Johns," *Art in America,* vol. 69, no. 6 (Summer 1981), p. 111.

81. Interview, November 1987.

82. Fuller, "Jasper Johns Interviewed: [Part] I," p. 6.

83. This component was identified by the artist as, more likely, a light of some kind (Interview, June 1988).

84. The last detail was taken from a newspaper photograph of Pope John Paul II during his visit to Auschwitz, with a warning sign of the skull and crossbones in the background (Francis, *Johns,* p. 94).

85. *Savarin,* 1982 (The Museum of Modern Art, New York, *Jasper Johns: A Print Retrospective* [May 20–August 19, 1986], p. 101).

86. Interview, August 1987.

87. Ibid.

88. Francis, *Johns,* p. 98.

89. Ibid., p. 94.

90. Interview, November 1987.

91. Described by the artist in Interview, August 1987. Francis reports that Johns wanted to include these in the first version of *Dancers on a Plane* (*Johns,* p. 95).

92. Similarly, Cage describes the rhythmic pattern of ballet, the way time is divided, and the clarity of these structures (*Silence,* p. 90); symmetry is often important as well, establishing a kind of zero point (p. 81).

93. Sylvester, "Interview," pp. 15–16.

94. For additional discussions on this subject, see Cuno, "Johns," p. 92, and Roni Feinstein, "New Thoughts for Jasper Johns' Sculpture," *Arts Magazine,* vol. 54, no. 8 (April 1980) pp. 139–43.

95. Compare Alberto Giacometti's *Spoon Woman,* 1926 (The Museum of Modern Art, New York, *Alberto Giacometti* [June 9–October 10, 1965], repro, p. 31). Johns had shown a spoon bathed in an inky darkness as an illustration in the O'Hara memorial volume (Frank O'Hara, *In Memory of My Feelings: A Selection of Poems by Frank O'Hara,* ed. Bill Berkson [New York, 1967], p. 11); also discussed by Cuno, in "Johns," p. 91. It may be said that the spoon and fork are bound together like lovers in *In Memory of My Feelings—Frank O'Hara,* 1961 (fig. 24). A similar juxtaposition of rigid and receptaclelike objects appears in *Zone,* 1961 (Crichton, *Johns,* pl. 101), in which a brush and cup are shown. Also, compare the artist's use of the broom and cup in *Fools' House,* 1962 (pl. 98).

96. Johns, "Sketchbook Notes," *Art and Literature,* p. 185.

97. Crichton, *Johns,* p. 56.

98. Johns recalled a spoon in Alfred Barr, *Fantastic Art: Dada and Surrealism* (New York, 1936), described as *Spoon Found in a Condemned Man's Cell.* He also recalled Duchamp's *The Locking Spoon,* 1957, which was attached to the deadbolt of a door as a locking mechanism: another title of a work by Duchamp is a pun: "From the Back of the Spoon to the Dowager's Ass" (Cuno, "Johns," p. 91.)

99. See p. 16

100. Cage, *Silence,* p. 76.

101. The drawing was made during a period when Johns was painting three canvases of the same title (see Francis, *Johns,* pp. 98–99). He explained that the drawing was done in order to transfer a reversal of the pattern of *Tantric Detail I* to a second canvas (Interview, August 1987).

102. See Shapiro, *Johns,* pp. 39–40. Compare also Munch's lithographs *Death and the Maiden,* 1894, and *Dance of Death,* 1915 (Hood Museum of Art, Dartmouth College, Hanover, N. H., *Encounter in Space: Double Images in the Graphic Art of Edvard Munch* [November 8, 1986–January 4, 1987], p. 9), in which eros and death are linked.

103. The Jewish Museum, *Johns,* p. 26. Johns used a transfer process to add the image of the skull to *Tantric Detail;* the testicles were drawn (Interview, August 1987).

104. Interview, August 1987.

105. Reproduced in Castleman, *Johns,* p. 120. Mark Lancaster notes a similarity in the "tangle of intrusion" with *Studio,* 1964 (Crichton, *Johns,* pl. 119), and *Harlem Light,* 1967 (pl. 129) (Lancaster to the author, November 1987).

106. Francis points out that Johns transposed the detail of Munch's coverlet onto the lower-right corner of each *Between the Clock and the Bed* (*Johns,* p. 100).

107. It is interesting to note that Beckett, in *Endgame,* emphasizes the motif of the clock (which is "Fit to wake the dead!"), as well as the bed and sleep, to which various of the characters want, frequently, to resort.

108. For discussion of Munch in relation to Johns, see Goldman, *17 Monotypes,* pp. 84–88.

109. In the manner of early Cubism Johns explores a figure-ground relationship in this series that produces two kinds of spatial planes; once lifted visually from their surroundings, the white-tinged focal configurations of the 1983 paintings and the orange patterns in the first two works might even be read as abstract, energetically gesticulating figures. In a related note Johns comments in his "Sketchbook Notes" (Francis, *Johns,* p. 109):

2 kinds of "space"
one on top of the other
and/or
one "inside" the other (Is one a detail of the other?)
one around the other
What can one do with "one includes the other"?
"something" can be either one thing or/another

110. Moira Roth, "The Aesthetic of Indifference," *Artforum,* vol. 16, no. 3 (November 1977), p. 52.

111. Max Kozloff, *Jasper Johns* (New York, 1967), p. 38; see also Bernstein, *Johns' Paintings and Sculptures,* p. 60. Roth also notes Johns's interest in Leonardo vis-à-vis his apparent indifference ("Indifference," p. 52).

112. Compare *Untitled,* 1977 (Shapiro, *Johns,* pl. 9). Although unintended (Interview, January 1988), the title *Voice* makes for an interesting comparison with the title of John Cage's book *Silence,* which was first published in 1939.

113. See also *Voice,* 1969 (Shapiro, *Johns,* pl. 102). With regard to works of art that possess a sound, one should recall Johns's *Untitled,* 1977 (Shapiro, pl. 9), and much earlier, Duchamp's *With Hidden Noise,* 1916 (Philadelphia Museum of Art, the Louise and Walter Arensberg Collection).

114. Geelhaar, *Johns,* p. 52.

115. At first, Johns used "unwoven" plastic material or fabric of some kind, also known as nylon film or frosted Mylar (see Shapiro, *Johns,* pls. 57, 81). See also Cage, *Silence,* p. 28.

116. Johns, "Sketchbook Notes," in Francis, *Johns,* p. 110.

117. Indeed Johns speaks of a "cyclical arrangement" with regard to this work (Interview, November 1987).

118. Ibid., September 1987. By this reference Johns, as a Surrealist, playfully recalls the "chance encounter of a sewing machine and an umbrella on a dissection table" described by the count of Lautreamont (William S. Rubin, *Dada and Surrealist Art* [New York, 1968], p. 36).

119. Recall *Untitled (Skull)* (fig. 13), *Weeping Women* (pl. 3), and *Dutch Wives* (fig. 14).

Dropping the Reserve: Work Since 1982

1. Peter Fuller, "Jasper Johns Interviewed: Part II," *Art Monthly* (London), no. 19 (September 1978), p. 7.

2. For example, in *Wall Piece,* 1968 (Crichton, *Johns,* pl. 136).

3. Johns, "Sketchbook Notes," in Francis, *Johns,* p. 110.

4. Lancaster compares the pattern to that of a harlequin's costume (Lancaster to the author, November 1987).

5. See, for example, *Still Life with Violin and Pitcher* (Kunstmuseum Basel).

6. Fuller, "Jasper Johns Interviewed: Part II," p. 7; see also Johns's statement in Geelhaar, *Johns,* p. 56.

7. Johns, "Sketchbook Notes," in Francis, *Johns,* p. 100.

8. This material is also used in the encaustic process (Francis, *Johns,* p. 101).

9. The Jewish Museum, *Johns,* p. 22.

10. The potential sources are many, including Duchamp's *Etant Donnés . . .* and his *Torture-Morte* (Philadelphia Museum of Art). For more on the latter possibility, see Bernstein, *Johns' Painting and Sculptures,* p. 83; and Roberta Bernstein, "An Interview with Jasper Johns," *New York Literary Forum,* vol. 8–9 (1981), p. 287.

11. The arm was cast from a child named John Huggins (Interview, August 1987). Lancaster explains that Johns made the casts, seen in *In the Studio, Perilous Night,* and *Untitled* well before having a painting in mind in which he would use them (Lancaster to the author, November 1987).

12. In this regard, consider Johns's use of the word "pinioned." See Fuller, "Jasper Johns Interviewed: Part II," p. 7.

13. Several of Johns's works are titled *Decoy* (see Crichton, *Johns,* p. 59, pls. 145, 146).

14. Johns describes noticing an unpainted canvas leaning against a wall, which he then wanted to introduce into a painting (Interview, August 1987). Similar "slates" appear elsewhere, including *No,* 1961 (Crichton, *Johns,* pl. 80), and *Zone,* 1962 (pl. 101).

15. Recall *Device Circle,* 1959 (fig. 38) and compare the placement of a stick over a circle with the composition in *In the Studio.*

16. The stick also recalls Johns's frequent use of rulers and other measuring devices that provide an impartial system of judgment. " 'A lot of things in my paintings are involved with measurement' . . . set against 'the immeasurability that art is supposed to have.' " (Grace Glueck, "No Business Like No Business," *New York Times,* January 16, 1966, p. 26).

17. Conjoined with the blank canvas, the stick can even be seen as the physical embodiment of Barnett Newman's characteristic "zip," or stripe, a quotation Johns would specifically cite in a number of subsequent works.

18. It was cast from the body of John Huggins (Interview, August 1987).

19. Johns saw the Grünewald alterpiece for the first time in 1976 (Interview, August 1987). The presence of the soldiers in *Perilous Night* was noted by John Yau in "Target Jasper Johns," *Artforum,* vol. 24, no. 4 (December 1985), pp. 84–85; Johnston discovered the fragment depicted to be of Saint Anthony ("Tracking the Shadow," pp. 128–43).

20. Castleman, *Johns,* p. 45.

21. Johnston points out that the music by Cage is one of his very few possessing a highly personal meaning ("Tracking the Shadow," p. 135).

22. "Whose broad stripes and bright stars through the perilous fight."

23. Yau calls the left half of the painting the location for the soldier/watchman to fall " 'into' the . . . trap of looking"

whereas the right is the spy's space ("Target," p. 84).

24. In his encaustic works, fragments of newsprint are usually quite visible. As in *Perilous Night,* Johns had combined largely abstract patterns with body casts in *Target with Plaster Casts,* 1955 (fig. 2).

25. James J. Gibson, *The Senses Considered as Perceptual Systems* (Boston, 1966), p. 256. Barbara Rose says that Gibson had an important influence on Johns ("Jasper Johns: Pictures and Concepts," *Arts Magazine,* vol. 52, no. 3 [November 1977], p. 153).

26. Crane, "Cape Hatteras," *Poems,* p. 81, line 134.

27. Kozloff, *Johns,* p. 38.

28. Sylvester, "Interview," p. 14.

29. Johns confirms that *Untitled* followed *Perilous Night* (pl. 18) (Interview, October 1987).

30. Lancaster to the author, November 1987.

31. This particular skull has the appearance of a reconfigured *Critic Sees,* 1961 (Crichton, *Johns,* pl. 90), for the jagged teeth are once more in the proper place, but the eye sockets are hollow.

32. Interview, August 1987. This identification was published by Johnston in "Tracking the Shadow," p. 132.

33. Ibid., p. 132. Johnston told the author that these words should have been recorded in quotes in her article (October 1987).

34. One is reminded of "Richard Mutt's" (probably Duchamp's) statement that "the only works of art America has given are her plumbing and bridges" (*Blind Man,* no. 2, 1917).

35. Compare *Dutch Wives* (fig. 14) for another work entitled with a double entendre.

36. Johns says this allusion is unintended (Interview, September 1987).

37. According to Johns, the order of pictures in 1983 was probably *Untitled, Racing Thoughts, Ventriloquist* (Interview, August 1987).

38. Newman's lithograph, *Untitled,* 1961, is owned by Johns (Ibid., September 1987).

39. Ibid. Johns had used such a line at least as early as *Diver,* 1962 (Crichton, *Johns,* pl. 106), and later in *Céline.* He derives this element from batons held by various conductors and ballet masters in works by Degas (Interview, September 1987), in which these

actions exist side by side with those of performers. In this regard, one could compare the dotted line in *Dancers on a Plane,* 1980 (pl. 10), and the stick in *In the Studio* (pl. 16).

40. Published in Berkeley and London by the University of California Press, 1979. The identification was first published by Yau, who also speaks of the whale as a Johnsian "watchman" ("Target," pp. 83–84).

41. These are in the collection of the artist (Interview, September 1987).

42. The vase is a celebratory one produced in Germany in 1977 (Francis, *Johns,* p. 106). See also *Racing Thoughts* (pl. 28).

43. Alison de Lima Green compared the situation to Jonah in the belly of a whale, in "Jasper Johns in the Museum Collection," *The Museum of Fine Arts, Houston, Bulletin,* vol. 10, no. 1 (Fall 1986), p. 28. Lancaster notes that in Latin "ventriloquist" means stomach [or belly] noise (Lancaster to the author, November 1987).

44. Lancaster notes that Johns first compared the forty-eight- and fifty-star flags in a lithograph created in 1980 for the fiftieth anniversary of the Whitney Museum of American Art in New York (Lancaster to the author, November 1987).

45. Lancaster notes that the images of body parts are, like the Newman work, all replications of lithographs (Ibid.).

46. Johns described the similarity as unintended (Interview, September 1987).

47. The segmentation and framing of parts are again reminiscent of Magritte, in this case *Eternal Evidence* (Sylvester, *Magritte,* p. 37).

48. Francis, *Johns,* p. 103.

49. During a scene of an interior Johns noticed a blurred image of a painting with black lines laid over it suggesting a second image. He said that this would be an economical way of making a painting, so he created arbitrary areas of color and then added other elements (Interview, September 1987).

50. *Untitled,* 1984 (encaustic on canvas, 13 1/4 × 10 1/2", collection the artist), preceded *Racing Thoughts,* 1984.

51. Compare Duchamp's *Wanted,* 1923 (Robert Lebel, *Marcel Duchamp,* trans. George Heard Hamilton [New York, 1959], p. 45, n. 1).

52. Bernstein, *Johns' Paintings and Sculptures,* p. 6.

53. Francis, *Johns,* p. 106. Johns had created his own ceremonial goblet in 1971–72, entitled *Cups 2 Picasso/Cups 4 Picasso,* in which the object subsumes

two profiles of the Spanish artist (Ibid.); of course, in his series of sculptures called *The Glass of Absinthe,* Picasso himself had pioneered in integrating profiles in an abstract construction. The ceramicist George Ohr, too, was known for his "poetic anthropomorphism" and creation of twin images. He called his work "Pot-Ohr-Ree" (Mississippi Department of Archives and History, *The Biloxi Art Pottery of George Ohr* [Jackson, 1978], p. 5).

54. "*L.H.O.O.Q.*" beneath the image is to be read as *Elle a chaud au cul.* See Lebel, *Marcel Duchamp,* p. 45, n. 1.

55. Leo Castelli makes this connection (Crichton, *Johns,* p. 69, n. 78).

56. Johns has gone even further in this regard in a pair of untitled works of 1986 (Robert and Jane Meyerhoff Collection, Phoenix, Md.), in which parts of a face are isolated and casually distributed on a large expanse. These works were in part influenced, according to the artist (Interview, September 1987), by Picasso's renderings of heads that date to the late 1930s.

57. "Ought" can be linked conceptually to Johns's longtime interest in what he calls given situations.

58. This description of events was given by the artist (Interview, September 1987).

59. See Geelhaar, *Johns,* p. 48.

60. Ibid. For more discussion on the parallel interests of Picasso and Johns, see New York, Leo Castelli Gallery, *Jasper Johns: The Seasons* [January 31–March 7, 1987], pp. 9–11.

61. In David Douglas Duncan, *Picasso's Picassos* (London, 1961), p. 182. Much has also been made of the similarities between Johns's shadow figure and a similar one in Picasso's *The Shadow* (Barbara Rose, "Jasper Johns: The Seasons," *Vogue* (January 1987), p. 199); which Johns saw at the exhibition "Picasso: Oeuvres reçues," Grand Palais, Paris (October 11, 1979–January 7, 1980) (Interview, November 1987, and Lancaster to the author, November 1987).

62. Interview, August 1987.

63. Rose, "The Seasons," p. 199. Judith Goldman states that his friend Julian Lethbridge traced the shadow of Johns, from which the cutout was made (Leo Castelli Gallery, *The Seasons,* p. 7).

64. For more on this subject, see Bernstein, "An Interview," pp. 279–90. Johns is known to have read Wittgenstein in depth and therefore might have been familiar with the philosopher's interest in the subject of the shadow (Ludwig Wittgenstein, *The Blue and the Brown Books* [Oxford, 1969], pp. 37ff).

65. Rose, "The Seasons," p. 199.

66. Lancaster notes that the device is also present in *Good Time Charley,* 1961 (Crichton, *Johns,* pl. 85), and that a cup, such as is seen in *Ventriloquist* and "The Seasons," is there as well (Lancaster to the author, November 1987). Duchamp also made extensive use of circular forms, which connote for him the endless boredom of life: "Slow life. Vicious circle. Onanism. . . . /Monotonous fly wheel. Beer professor" (from Duchamp's own notes for his *Green Box* [Philadelphia Museum of Art]).

67. Johns speaks of the "infantile level" of understanding vis-à-vis a whole (Fuller, "Jasper Johns Interviewed: Part II," p. 7).

68. The decoy duck is present in the writings of Ludwig Wittgenstein (Rose, "The Seasons," p. 259). It is perhaps this rabbit that was referred to when Johns wrote: "What can one do with 'one inside the other'?/something' can be either 1 thing or another/(without turning the rabbit on its side)" (Johns, "Sketchbook Notes," in Francis, *Johns,* p. 109).

69. This silhouette was drawn from a tracing made of the shadow of three-year-old Andrew Monk (Leo Castelli Gallery, *The Seasons,* p. 11).

70. Rose identifies the brick floor as based on Johns's house in Stony Point ("The Seasons," p. 259).

71. Johns reports that while working on *Summer,* which at the time was not imagined to be part of "The Seasons," he was most interested in depicting the seasonal effects of summer in St. Martin (Interview, September 1987).

72. Johns recalls seeing similar shapes in a zen brush drawing and being struck by the freedom of rendering as compared to the usage by Cézanne (Interview, November 1987).

73. Leo Castelli Gallery, *The Seasons,* p. 7.

74. Rose, "The Seasons," p. 259; Johns confirmed that he intentionally used the childbearing male seahorse as a substitute for Picasso's pregnant horse. He also reported that he was attracted to this motif because it was not one of his possessions, unlike the rest of the elements in the painting (Interview, September 1987).

75. Rose, "The Seasons," p. 259.

76. Rose identifies the wooden floor in this image as that of Johns's Houston Street studio in New York City (Ibid., p. 259).

77. See Max Kozloff, "Johns and Duchamp," *Art International,* vol. 8, no. 2 (March 20, 1964), p. 42, n. 1.

78. Interview, September 1987.

79. Johns has confirmed this reading (Interview, September 1987).

80. Bernstein, *Johns,* pp. 69, 111.

81. Rose has proposed that the geometrical forms are derived from Dürer's *Melancholia,* in which the figure stares at the symbols and tools of geometry ("The Seasons," p. 259). This idea is an intriguing one, for Dürer's image is concerned with the kind of speculative, intellectual thought and melancholic mood that typify Johns's approach, and the fall-type individual tends, notwithstanding her mood, to be outstanding in the areas of geometry and science. Opposed to the geometrical objects, Dürer arranged a group of alchemists' pots; he also included a large ladder. Furthermore, he juxtaposed a man in thought with a skull in *St. Jerome in his Cell,* just as Cézanne had done. Notwithstanding these comments, Johns himself says that he was not consciously aware of the similarities to Dürer (Interview, September 1987).

82. In this regard, the double spoon may be understood as signifying the divided state of the individual.

83. *Fall* might be compared to the composition of *The Threatened Assassin* by Magritte (Sylvester, *Magritte,* p. 111).

84. Rose says the floor here is based on stones in the courtyard of Johns's East Side, New York, studio ("The Seasons," p. 259).

85. Winter is on occasion shown as a female personification, wrapped in heavy garments for protection against the cold and carrying a duck or hare. See M. Veldman, "Seasons, Planets and Temperaments in the Work of Maarten van Heemskerck. Cosmo-Astrological Allegory in Sixteenth-Century Netherlandish Prints," *Simiolus,* vol. 11, no. 3-4 (1980), p. 151.

86. Rose says Johns was impressed, in particular, by a Japanese screen that he saw at the Freer Gallery of Art, Smithsonian Institution, Washington, D.C. depicting The Seasons ("The Seasons," p. 259).

87. Raynor, "Johns," p. 21.

88. We have already noted his admiration of Cézanne and borrowings from Picasso but not mentioned his possession of a 1913 drawing by Juan Gris (observed by the author, 1987). For more on the place of Cubism in Johns's work, see Bernstein, *Johns,* pp. 22, 31, 34, 37, 44, 68, 71.

89. Rose, "The Seasons," p. 260.

Solo Exhibitions Since 1974

1974

Galerie de Gestlo, Hamburg. "Jasper Johns: Graphik." January 7–February 2.

Lo Spazio, Galleria d'Arte, Rome. "Jasper Johns." February.

Lucio Amelio, Modern Art Agency, Naples. "Jasper Johns: Prints, 1960–1972." February.

Gemini G.E.L., Los Angeles. "New Series of Lithographs by Jasper Johns." March.

Christ Janer Gallery, New Canaan, Connecticut. "Jasper Johns: Selected Graphics." April–May.

Museum of Modern Art, Oxford. "Jasper Johns Drawings." September 7–October 13. Traveled to Mappin Art Gallery, Sheffield, October 19–November 17; Herbert Art Gallery, Coventry, November 30–December 29; Walker Art Gallery, Liverpool, January 4, 1974–February 2, 1975; City Art Gallery, Leeds, February 8–March 9, 1975; Serpentine Gallery, London, March 20–April 20, 1975.*

Castelli Graphics, New York. "Jasper Johns: Recent Four Panel Prints." September 21–October 5.

Knoedler, New York. "Jasper Johns: 1st Etchings, 1st State and 1st Etchings, 2nd State." October 19–November 29.

1975

Minami Gallery, Tokyo. "Jasper Johns Drawings." October 27–November 15.*

Gemini G.E.L., Los Angeles. "Jasper Johns Lithographs 1973–1975." n.d.*

1976

Leo Castelli Gallery, New York. "Jasper Johns." January 24–February 14.

Janie C. Lee Gallery, Houston. "Jasper Johns: Prints 1960–1974." February.

Getler/Pall, New York. "Jasper Johns: Prints 1973–1976." May 4–29.

Wadsworth Atheneum, Hartford. "Jasper Johns: MATRIX 30." May 15–July 1.*

Gemini G.E.L., Los Angeles. "Jasper Johns: Six New Color Lithographs." December.

1977

Blum Helman Gallery, New York. "Jasper Johns: Graphic Work." October.

Whitney Museum of American Art, New York. "Foirades/Fizzles." October 11–November 20.*

Castelli Graphics, New York. "Jasper Johns: Prints." October 15–November 12.

Whitney Museum of American Art, New York. "Jasper Johns." October 17, 1977–January 22, 1978. Traveled to Museum Ludwig, Cologne, February 10–March 26, 1978; Musée National d'Art Moderne, Paris, April 18–June 4, 1978; Hayward Gallery, London, June 21–July 30, 1978; The Seibu Museum of Art, Tokyo, August 19–September 26, 1978; San Francisco Museum of Modern Art, October 20–December 10, 1978.*

Getler/Pall, New York. "Jasper Johns: Prints." October 22–November 19.

Mary Porter Sesnon Art Gallery, University of California, Santa Cruz. "Jasper Johns: A Retrospective Exhibition of Prints, 1960–1976." November 2–December 10.

Brooke Alexander, Inc., New York. "Jasper Johns Screenprints." November 15, 1977–January 7, 1978. Traveled to Akron Art Museum, December 8, 1978–January 21, 1979; Seattle Art Museum, February 1–March 18, 1979; Centre for the Arts, Simon Fraser Gallery, Burnaby, British Columbia, Canada, April 2–May 13, 1979; Phoenix Art Museum, May 27–July 8, 1979; Portland Art Museum, Oregon, July 23–September 16, 1979; San Jose Museum of Art, California, October 1–November 11, 1979; Tucson Museum of Art, December 8, 1979–January 13, 1980; Roswell Museum and Art Center, New Mexico, January 21–March 2, 1980; University Art Gallery, University of Texas, Arlington, March 17–April 27, 1980; Arkansas Arts Center, Little Rock, May 12–June 22, 1980; Tyler Museum of Art, Texas, July 7–September 7, 1980; Center for the Visual Arts Gallery, Illinois State University, Normal, September 22–November 9, 1980; The Toledo Museum of Art, November 24–January 4, 1981; J. B. Speed Art Museum, Louisville, Kentucky, January 19–March 1, 1981; Springfield Art Museum, Missouri, March 16–April 26, 1981.*

Whitney Museum of American Art (Downtown Branch), New York. "Jasper Johns Prints: Three Images." December 14, 1977–January 17, 1978.

1978

Museum of Fine Arts, Boston. "Jasper Johns: First Etchings." January 14–March 12.

Margo Leavin Gallery, Los Angeles. "After Untitled 1974–1977." March 18–April 29.

Wesleyan University, Middletown, Connecticut. "Jasper Johns: Prints 1970–1977." March 27–April 25. Traveled to Springfield Museum of Art, Massachusetts, May 10–June 25; Baltimore Museum of Art, July 11–August 20; Dartmouth College Museum and Galleries, Hanover, New Hampshire, September 8–October 15; University Art Museum, University of California, Berkeley, November 3–December 15; Cincinnati Art Museum, January 5–February 16, 1979; Georgia Museum of Art, Athens, March 9–April 20, 1979; The Saint Louis Art Museum, May 11–June 22, 1979; Newport Harbor Art Museum, California, July 13–September 9, 1979; Rhode Island School of Design Museum of Art, Providence, October 3–November 18, 1979.*

Galerie Nancy Gillespie-Elisabeth de Laage, Paris. "Jasper Johns: Estampes, 1967–1978." April 20–May 18.

Galerie Valeur, Nagoya, Japan. "Jasper Johns: Lead Reliefs." July 1–29.

Galerie Mukai, Tokyo. "Jasper Johns Screenprints." August 21–September 9.

John Berggruen Gallery, San Francisco. "Jasper Johns: Prints and Drawings." October 20–November 25.

1979

Janie C. Lee Gallery, Houston. "Jasper Johns: Drawings and Prints 1975–1979." April.

Kunstmuseum Basel. "Jasper Johns Working Proofs." April 7–June 2. Traveled to Staatliche Graphische Sammlung, Munich, June 19–August 5; Städelesches Kunstinstitut, Frankfurt, September 13–November 11; Kunstmuseum mit Sammlung Sprengel, Hannover, West Germany, November 25–January 6, 1980; Den Kongelige Kobberstiksamling Statens Museum for Kunst, Copenhagen, January 19–March 16, 1980; Moderna Museet, Stockholm, March 29–May 11, 1980; Centre Cultural de la Caixa de Pensions, Barcelona, October 2–November 2, 1980; Provinciaal Museum Begijnhof, Hasselt, Belgium, November 21–January 4, 1981; The Tate Gallery, London, February 3–March 22, 1981.*

Galerie Valeur, Nagoya, Japan. "Jasper Johns: Prints and Drawings." September 3–29.

Little Center Gallery, Clark University, Worcester, Massachusetts. "Jasper Johns' Graphics." September 24–October 11.

Getler/Pall, New York. "Jasper Johns: Lithographs." November 6–December 15.

1980

Castelli Graphics, New York. "Jasper Johns." January 19–February 9.

Frumkin & Struve, Chicago. "Jasper Johns: Major Graphics." December 13, 1980–January 9, 1981.

Getler/Pall Gallery and Patricia Heesy Fine Art, New York. "Jasper Johns: Color Numeral Series, 1969." December 30, 1980–January 24, 1981.

1981

Leo Castelli Gallery, New York. "Jasper Johns Drawings 1970–1980." January 10–February 7. Traveled to Margo Leavin Gallery, Los Angeles, February 21–March 28.

The Greenberg Gallery, St. Louis. "Jasper Johns Prints." February.

Gillespie-Laage-Salomon, Paris. "Jasper Johns: Estampes Récentes." February 19–March 25.

Thomas Segal Gallery, Boston. "Jasper Johns Prints 1977–1981." October 24–December 2.*

1982

Castelli Graphics, New York. "Two Themes: Usuyuki and Cicada." January 9–30.

L. A. Louver Gallery, Venice, California. "Jasper Johns." February 16–March 13.

McKissick Museums, University of South Carolina, Columbia. "Jasper Johns . . . Public and Private." August 20–October 3.*

Whitney Museum of American Art, New York. "Jasper Johns: Savarin Monotypes." November 10, 1982–January 9,

1983. Traveled to Dallas Museum of Art, March 31–May 20, 1984; Moderna Galerija, Ljubljana, Yugoslavia, June 1–30, 1985; Kunstmuseum Basel, September 14–November 10, 1985; Sonja Henie Niels Onstad Foundation, Oslo, Norway, December 1985–January 1986; Heland Thorden Wetterling Galerie, Stockholm, February–March, 1986; The Tate Gallery, London, May 28–August 31, 1986.

1983

Akira Ikeda Gallery, Tokyo. "Jasper Johns: Selected Prints." October 3–29.

Delahunty Gallery, Dallas. "Jasper Johns: Prints." November 12–December 14.

1984

Leo Castelli Gallery, New York. "Jasper Johns Paintings." January 28–February 25.

1985

Brook Alexander, Inc., New York. "Jasper Johns: Trial Proofs and Proofs with Editions." April 5–May 3.

Lorence Monk Gallery, New York. "Jasper Johns: The Screenprints 1968–1982." July 9–August 23.

Lorence Monk Gallery, New York. "Jasper Johns: Foirades/Fizzles." September 14–October 5.

The Saint Louis Art Museum. "Jasper Johns: Currents 30." November 20, 1985–January 5, 1986.*

1986

Patricia Heesy Gallery, New York. "Jasper Johns: Selected Prints." May 13–June 14.

Fondation Maeght, St. Paul de Vence, France, "Jasper Johns: L'Oeuvre Graphique de 1960 à 1985." May 17–June 30.

The Museum of Modern Art, New York. "Jasper Johns: A Print Retrospective." May 20–August 19. Traveled to Schirn Kunsthalle, Frankfurt, November 12, 1986–January 25, 1987; Centro Reina Sofia, Madrid, February 9–April 5, 1987; Wiener Secession, Vienna, May 5–June 8, 1987; The Fort Worth Art Museum, Texas, July 9–September 6, 1987; Los Angeles County Museum of Art, October 1–December 6, 1987.*

Pence Gallery, Santa Monica, California. "Jasper Johns: Prints." November 26, 1986–January 10, 1987.

1987

Leo Castelli Gallery, New York. "Jasper Johns: The Seasons." January 31–March 7.*

The Grunewald Center for the Graphic Arts, Wight Art Gallery, University of California, Los Angeles. "Foirades/Fizzles: Echo and Allusion in the Art of Jasper Johns." September 20–November 15. Traveled to Walker Art Center, Minneapolis, December 6, 1987–January 31, 1988; Archer M. Huntington Gallery, University of Texas, Austin, February 15–March 28, 1988; Yale University Art Gallery, New Haven, Connecticut, April 12–June 1, 1988; High Museum of Art, Atlanta, September 6–November 27, 1988.*

Galerie Daniel Templon, Paris. "The Drawings of Jasper Johns from the Collection of Toiny Castelli." October 23–November 25.

Neuberger Museum, State University of New York, Purchase. "Jasper Johns: Numerals in Prints." November 15, 1987–February 14, 1988.*

Lorence Monk Gallery, New York. "Jasper Johns: Lead Reliefs." December 12, 1987–January 9, 1988.*

1988

Greg Kucera Gallery, Seattle. "Jasper Johns: 'The Seasons.' Etchings from U.L.A.E." January 7–30.

The French Institute/Alliance Française, New York. "Foirades/Fizzles." January 22–February 27.

* A catalogue or brochure accompanied the exhibition

Selected Bibliography

Interviews, Statements

Bernard, April, and Mimi Thompson. "Johns On" *Vanity Fair,* vol. 47 (February 1984), p. 65.

Bernstein, Roberta. "An Interview with Jasper Johns." In *Fragments: Incompletion & Discontinuity,* ed. Lawrence D. Kritzman. New York, 1981, pp. 279–290.

Bourdon, David. "Jasper Johns: 'I Never Sensed Myself as Being Static.'" *The Village Voice,* October 31, 1977, p. 75.

Davvetas, Demosthéne. "Jasper Johns et sa famille d'objets." *Art Press,* vol. 80 (April 1984), pp. 11–12.

Fuller, Peter. "Jasper Johns Interviewed: [Part] I." *Art Monthly,* vol. 18 (July–August 1978), pp. 6–12.

————. "Jasper Johns Interviewed: Part II," *Art Monthly,* vol. 19 (September 1978), pp. 5–7.

Geelhaar, Christian. "Interview with Jasper Johns." In *Jasper Johns: Working Proofs.* London, 1980, pp. 37–56.

Hopps, Walter. "An Interview with Jasper Johns." *Artforum,* vol. 3, no. 6 (March 1965), pp. 32–36.

Johns, Jasper. "Duchamp." *Scrap,* 2 (December 23, 1980), p. 4.

————. "Marcel Duchamp (1887–1968): An Appreciation." *Artforum,* vol. 7, no. 3 (November 1968), p. 6.

————. "Sketchbook Notes." *Art and Literature,* vol. 4 (Spring 1965), pp. 185–192. (Reprint. Barbara Rose, ed. *Readings in American Art 1900–1975.* New York, 1975, pp. 176–178.)

————. "Sketchbook Notes." *Juilliard,* vol. 3 (Winter 1968–69), pp. 25–27. (Reprint. Richard Francis. *Jasper Johns.* New York, 1984, pp. 109–111.)

————. "Sketchbook Notes." *0 to 9,* no. 6 (July 1969), pp. 1–2. (Reprint. Richard Francis. *Jasper Johns.* New York, 1984, pp. 111–112.)

————. Statement in Emile De Antonio and Mitch Tuchman. *Painters Painting.* New York, 1984, pp. 86–87, 96–100, 102.

————. Statement in Grace Glueck, "The 20th-Century Artists Most Admired by Other Artists." *Artnews,* vol. 76, no. 9 (November 1977) pp. 87–89.

————. Statement in New York, The Museum of Modern Art. *Sixteen Americans,* ed. Dorothy Miller, pp. 22–27. December 16, 1959–February 14, 1960. (Reprint. Barbara Rose, ed. *Readings in American Art Since 1900: A Documentary Survey.* New York, 1968, pp. 165–166.)

————. "Thoughts on Duchamp." *Art in America,* vol. 57, no. 4 (July–August 1969), p. 31.

Pohlen, Annelie. "Interview mit Jasper Johns." *Heute Kunst,* no. 22 (May–June 1978), pp. 21–22.

Raynor, Vivien. "Jasper Johns." *Artnews,* vol. 72, no. 3 (March 1973), pp. 20–22.

Sylvester, David. "Interview." In London, Arts Council of Great Britain. *Jasper Johns Drawings,* pp. 7–19. Museum of Modern Art, Oxford, September 7–October 13, 1974.

Monographs, Exhibition Catalogues

Bernstein, Roberta. *Jasper Johns' Paintings and Sculptures 1954–1974.* Ann Arbor, Michigan, 1985.

Boston, Thomas Segal Gallery. *Jasper Johns Prints 1977–1981.* October 24–December 2, 1981. Text by Judith Goldman.

Crichton, Michael. *Jasper Johns.* New York, 1977.

Field, Richard S. *Jasper Johns: Prints, 1960–1970.* New York, 1970.

Francis, Richard. *Jasper Johns.* New York, 1984.

Geelhaar, Christian. *Jasper Johns Working Proofs.* London, 1980.

Goldman, Judith. *Jasper Johns: 17 Monotypes.* West Islip, New York, 1982.

Jasper Johns Drawings. London, Arts Council of Great Britain. Museum of Modern Art, Oxford, September 7–October 13, 1974.

Kozloff, Max. *Jasper Johns.* New York, 1969.

Los Angeles, The Grunewald Center for the Graphic Arts, Wight Art Gallery, University of California, Los Angeles. *Foirades/Fizzles: Echo and Allusion in the Art of Jasper Johns.* September 20–November 15, 1987.

Middletown, Conn., Center for the Arts, Wesleyan University. *Jasper Johns: Prints 1970–1977.* March 27–April 25, 1978. Text by Richard S. Field.

New York, The Jewish Museum. *Jasper Johns.* February 16–April 12, 1964. Text by Alan R. Solomon.

New York, Leo Castelli Gallery. *Jasper Johns: The Seasons.* January 31–March 7, 1987. Text by Judith Goldman.

New York, The Museum of Modern Art. *Jasper Johns: A Print Retrospective.* May 20–August 19, 1986. Text by Riva Castleman.

New York, Whitney Museum of American Art. *Foirades/Fizzles.* October 11–November 20, 1977. Text by Judith Goldman.

Shapiro, David. *Jasper Johns: Drawings 1954–1984.* New York, 1984.

Tono, Yoshiaki. *Jasper Johns and/or.* Tokyo, 1979.

Articles and Other Publications

Amaya, Mario. "The Right Stuff." *Studio International,* vol. 197, no. 1005 (1984), pp. 12–13.

Bernstein, Roberta. "Jasper Johns and the Figure." *Arts Magazine,* vol. 52, no. 2 (October 1977), pp. 142–144.

————. "Johns and Beckett: Foirades/Fizzles." *The Print Collector's Newsletter,* vol. 7, no. 5 (November–December 1976), pp. 141–145.

Brandt, Frederick R. "Jasper Johns." In *Late 20th-Century Art. Selections from the Sydney and Frances Lewis Collection in the Virginia Museum of Fine Arts.* Richmond, 1985, pp. 114–115.

Calas, Nicolas. "Jasper Johns and the Critique of Painting." *Punto de contacto,* vol. 1, no. 3 (September–October 1976), pp. 50–57.

————. "Jasper Johns ou: 'ceci n'est pas un drapeau.'" *XXe siécle,* vol. 50 (June 1978), pp. 33–39.

Cuno, James. "Jasper Johns." *Print Quarterly,* vol. 4, no. 1 (March 1987), pp. 83–92.

De Lima Green, Alison. "Jasper Johns in the Museum Collection." *The Museum of Fine Arts, Houston, Bulletin,* vol. 10, no. 1 (Fall 1986), pp. 26–31.

Feinstein, Roni. "Jasper Johns." *Arts Magazine,* vol. 55, no. 8 (April 1981), p. 7.

Francis, Richard. "Disclosures." *Art in America,* vol. 72, no. 8 (September 1984), pp. 196–202.

Gablik, Suzi. "Jasper Johns's Pictures of the World." *Art in America,* vol. 66, no. 1 (January–February 1978), pp. 62–69.

Geelhaar, Christian. "Ein Dritter Jasper Johns." *Basler Zeitung,* no. 126, June 1, 1979, p. 45.

Glueck, Grace. "'Once Established,' Says Jasper Johns, 'Ideas Can Be Discarded.'" *The New York Times,* October 16, 1977, sec. 2, pp. 1ff.

Harrison, Charles, and Fred Orton. "Jasper Johns: 'Meaning What You See.'" *Art History,* vol. 7, no. 1 (March 1984), pp. 78–101.

Hermann, Rolf-Dieter. "Johns the Pessimist." *Artforum,* vol. 16, no. 2 (October 1977), pp. 26–33.

Hess, Thomas B. "On the Scent of Jasper Johns." *New York Magazine,* vol. 9, no. 6 (February 9, 1976), pp. 65–67.

Johnston, Jill. "Tracking the Shadow." *Art in America,* vol. 75, no. 10 (October 1987), pp. 128–143.

Krauss, Rosalind. "Jasper Johns: The Functions Of Irony." *October,* vol. 2 (Summer 1976), pp. 91–99.

Kuspit, Donald. "Personal Signs: Jasper Johns." *Art in America,* vol. 69, no. 6 (Summer 1981), pp. 111–113.

Larson, Kay. "Antidotes to Irony." *New York Magazine,* vol. 17, no. 9 (February 27, 1984), pp. 58–59.

————. "The Game of the Rules." *New York Magazine,* vol. 14, no. 5 (February 2, 1981), pp. 54–55.

Masheck, Joseph. "Jasper Johns Returns." *Art in America,* vol. 64, no. 2 (March–April 1976), pp. 65–67. (Revised. "Coming to Terms with Later Johns." In *Historical Present: Essays of the 1970s.* Ann Arbor, Mich., 1984, pp. 109–113.)

Olson, Roberta J. M. "Jasper Johns." *SoHo Weekly News,* November 3–9, 1977, pp. 24–25.

Perrone, Jeff. "Jasper Johns's New Paintings." *Artforum,* vol. 14, no. 8 (April 1976), pp. 48–51.

———. "The Purloined Image." *Arts Magazine,* vol. 53, no. 8 (April 1979), pp. 135–139.

Phillips, David. *Five Modern Paintings from the Tate Gallery: Salvador Dali, Pierre Bonnard, George Grosz, Pablo Picasso, Jasper Johns.* London, 1984.

Prinz, Jessica. "Foirades/Fizzles/Beckett/Johns." *Contemporary Literature,* vol. 21, no. 3 (1980), pp. 480–510.

Ratcliff, Carter. "The Inscrutable Jasper Johns." *Vanity Fair,* vol. 47 (February 1984), pp. 60–64.

Reynolds, Ann Morris. "Jasper Johns." *Arts Magazine,* vol. 58, no. 8 (April 1984), p. 7.

Rose, Barbara. "Decoys and Doubles: Jasper Johns and the Modernist Mind." *Arts Magazine,* vol. 50, no. 9 (May 1976), pp. 68–73.

———. "Jasper Johns: Pictures and Concepts." *Arts Magazine,* vol. 52, no. 3 (November 1977), pp. 148–153.

———. "Jasper Johns—The Seasons." *Vogue* (January 1987), pp. 192ff.

Rosenberg, Harold. "The Art World: Twenty Years of Jasper Johns." *The New Yorker,* vol. 53, no. 45 (December 26, 1977), pp. 42–45.

Roth, Moira. "The Aesthetic Indifference." *Artforum,* vol. 16, no. 3 (November 1977), pp. 46–53.

Russell, John. "Art: Jasper Johns Show Is Painter at His Best." *The New York Times,* February 3, 1984, sec. C, p. 22.

———. "Gallery View: The Provocative Drawings of Jasper Johns." *The New York Times,* January 25, 1981, sec. D, p. 25.

———. "Jasper Johns Stretches Himself—and Us." *The New York Times,* February 1, 1976, sec. 2, pp. 1ff.

———. " 'The Seasons': Forceful Paintings from Jasper Johns." *The New York Times,* February 6, 1987, sec. C, pp. 1ff.

Smith, Roberta. "Jasper Johns's Personal Effects." *Village Voice,* February 21, 1984, p. 89.

Steinberg, Leo. "Contemporary Art and the Plight of Its Public." In *Other Criteria.* New York, 1972, pp. 3–16.

———. "Jasper Johns: The First Seven Years of His Art." In *Other Criteria.* New York, 1972, pp. 17–54.

Stevens, Mark, with Cathleen McGuigan. "Super Artist: Jasper Johns, Today's Master." *Newsweek,* vol. 90, no. 17 (October 24, 1977), pp. 66ff.

Sweet, David. "Johns's Expressionism." *Artscribe,* vol. 12 (June 1978) pp. 41–45.

Tomkins, Calvin. "The Art World: Passage." *The New Yorker,* vol. 62, no. 24 (August 4, 1986), pp. 72–76.

Welish, Marjorie. "Frame of Mind: Interpreting Jasper Johns." *Art Criticism,* vol. 3, no. 2 (1987), pp. 71–87.

White, Edmund. "Enigmas and Double Visions." *Horizon,* vol. 20, no. 2 (October 1977), pp. 49–55.

Yau, John. "Jasper Johns." *Artforum,* vol. 25, no. 9 (May 1987), pp. 142–143.

———. "Target Jasper Johns." *Artforum,* vol. 24, no. 4 (December 1985), pp. 80–84.

Index of Works by Jasper Johns